Yellowstone:
NEAR, FAR & WILD

A comprehensive look at our first national park,
including the Tetons

David Peterson

ISBN 10: 1-59152-130-0
ISBN 13: 978-1-59152-130-3
Published by David Peterson
© 2014 by David Peterson

For more information contact: www.photographerinthemidst.com

You may order extra copies of this book by calling Farcountry Press
toll free at (800) 821-3874.

sweetgrassbooks
a division of Farcountry Press

Produced by Sweetgrass Books.
PO Box 5630, Helena, MT 59604; (800) 821-3874;
www.sweetgrassbooks.com.

Created, produced and designed in the United States.
Printed in China.

18 17 16 15 14 1 2 3 4 5

Front and back covers (background):
Somewhere over Midway Geyser Basin.

Front cover (insets): A wolf in Hayden Valley circling
a lone bison; Lower Falls of the Yellowstone River.

Back cover (inset): Grizzly bear on a bull elk
carcass.

Following pages: The Grand Canyon of the
Yellowstone River and Lower Falls.

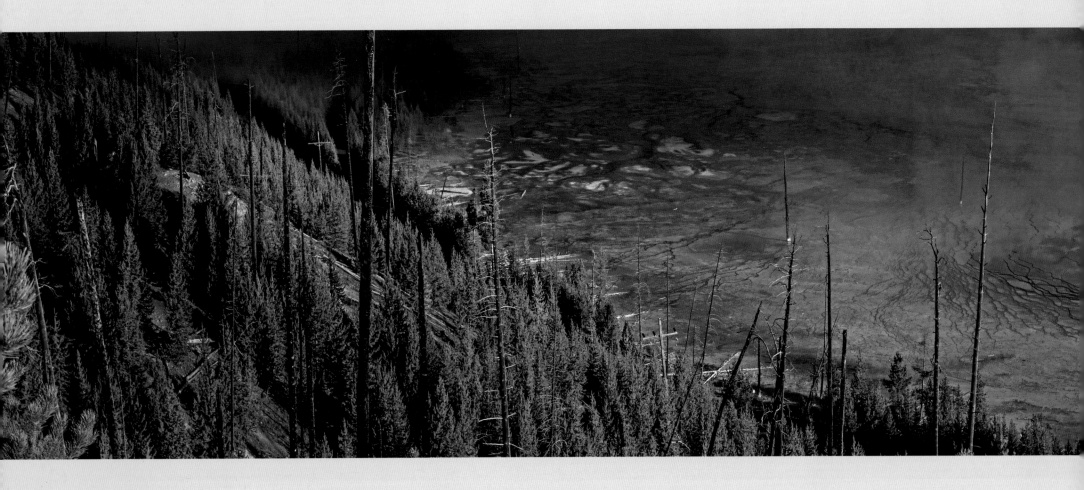

If you mention the word Yellowstone, some people's thoughts immediately turn to Old Faithful or possibly one of the many other geothermal features in the area. Others, when playing this word association game, undoubtedly think: bears. After all, Yellowstone is one of the few remaining places left in the lower forty-eight that remains home to any sizeable grizzly population—not to mention all the other animal species found there.

A few might even envision its namesake river, which flows from the largest high-country lake in North America, plunging 308 feet into a canyon comprised of (what else?) yellow stone. Still others see this incredible place for the hiking challenges that the over two million acres of nearly pristine backcountry offers, the result of an historic experiment in wilderness preservation.

There is no right answer; Yellowstone is, of course, all of the above—and more. It's a collection of curiosities and awe-inspiring scenes that, when paired with the Tetons, is unparalleled—and, for that matter, a real challenge to photograph. The following portfolio will therefore touch on as many aspects of Yellowstone as 130 pages will allow. It's an attempt to show all of the park's many moods—NEAR, FAR & WILD.

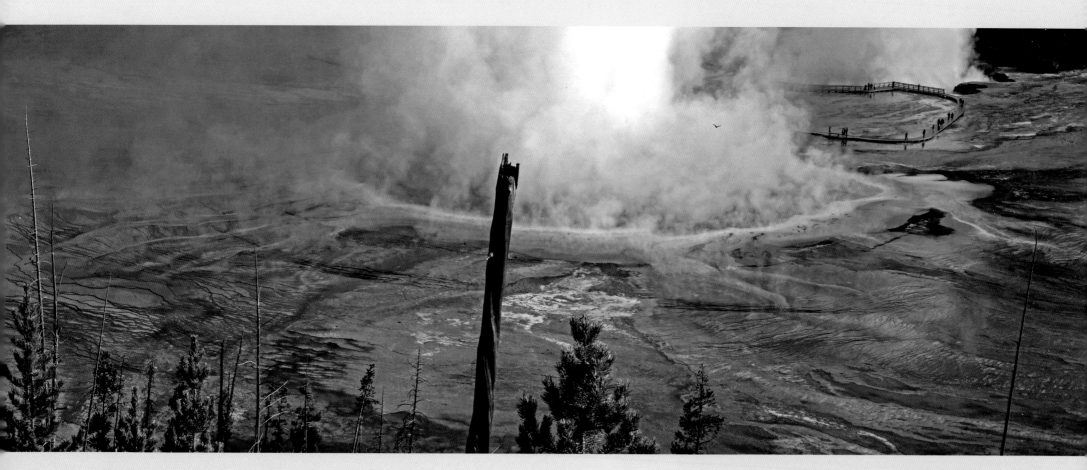

Grand Prismatic Spring.

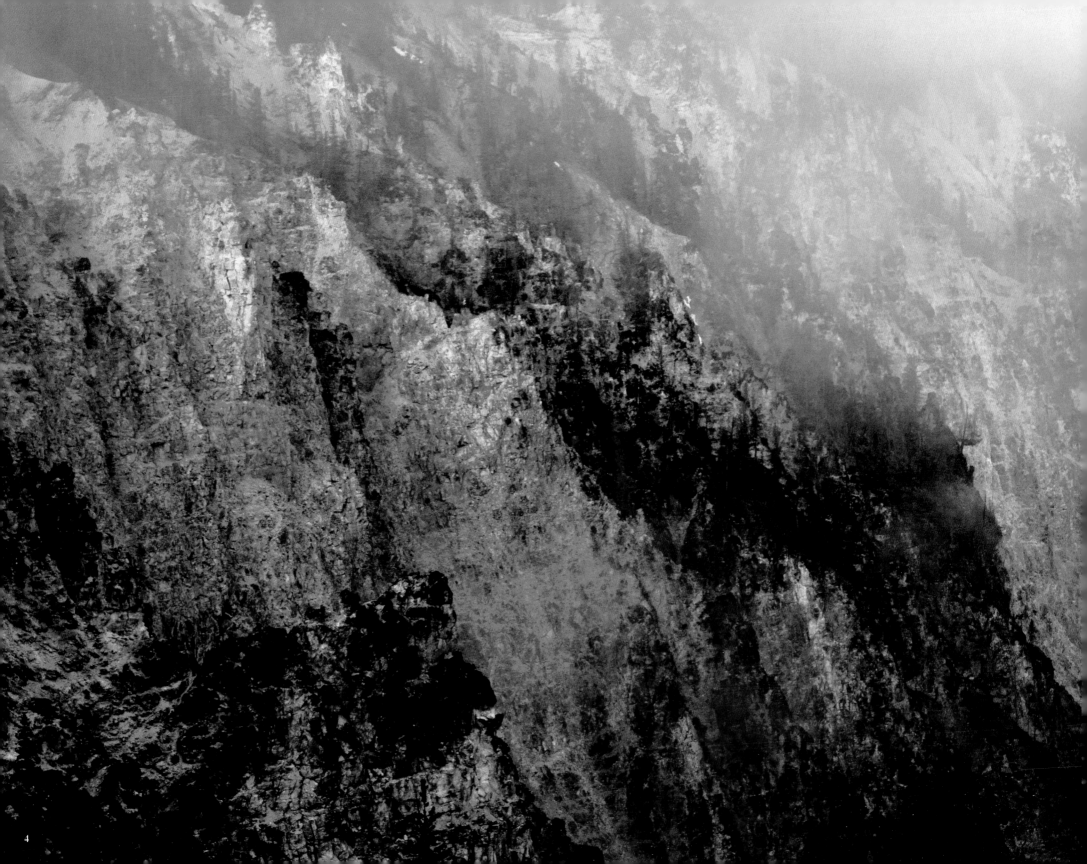

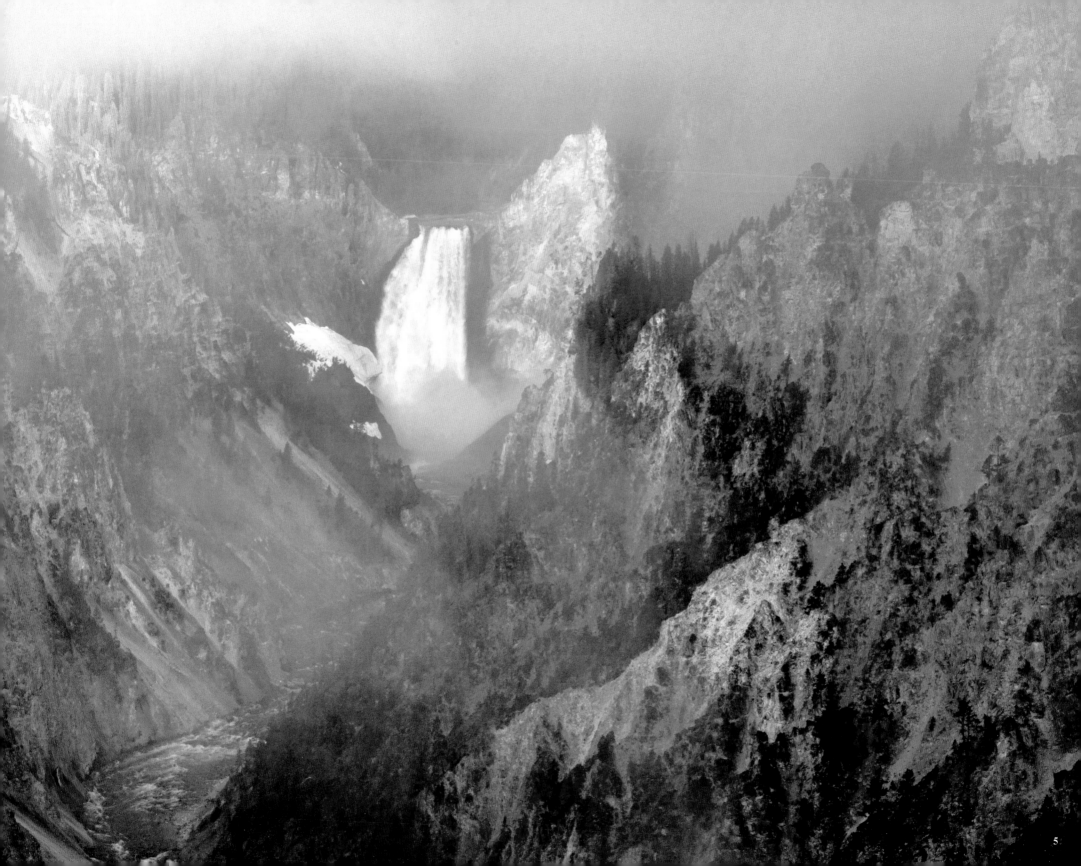

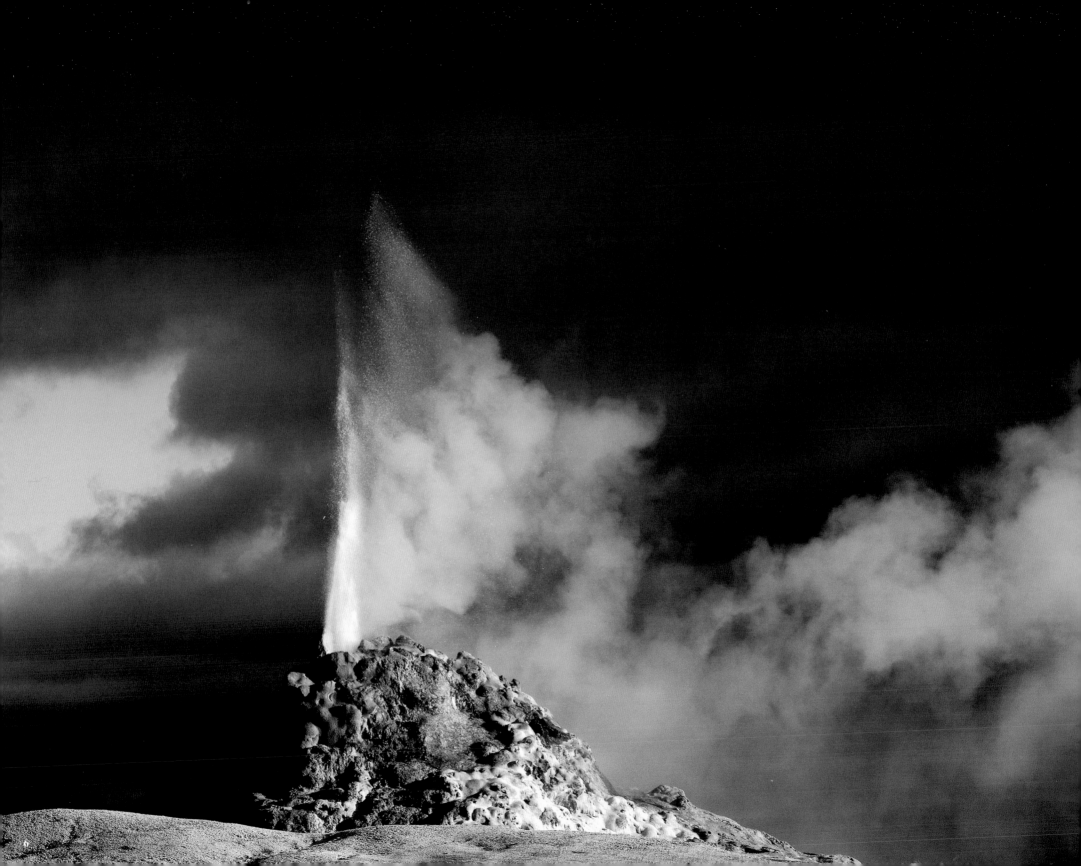

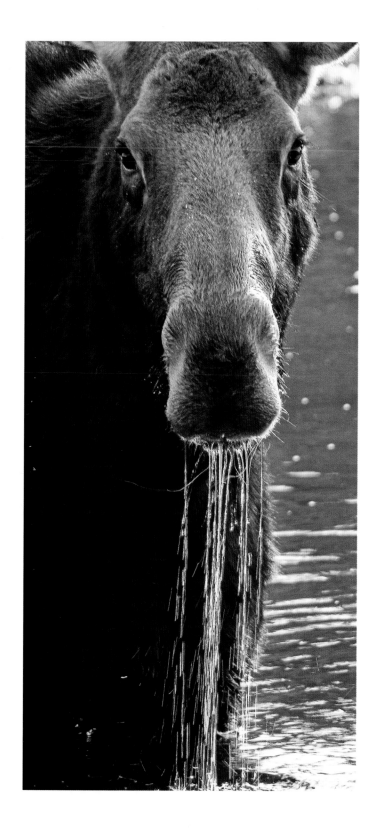

Above: The remote east shore of Yellowstone Lake is accessible only by foot or by boat.

Left: Moose can still sometimes be found drooling in Yellowstone Lake. Many of them have migrated south to the Tetons, though, where this cow was photographed.

Facing page: White Dome Geyser erupts against the backdrop of stormy skies.

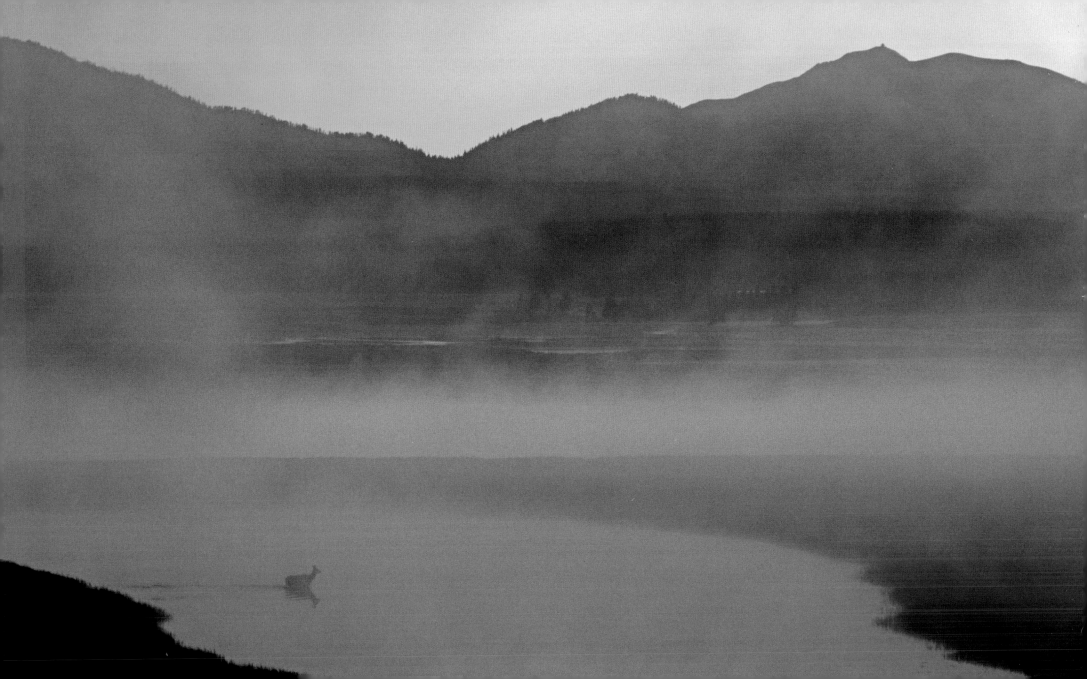

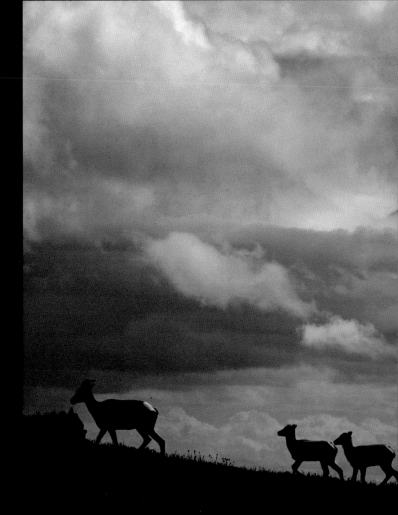

Left: A lone cow elk makes her way
across a Yellowstone River tributary
in Hayden Valley. Mount Washburn
and its fire lookout tower can be
seen in the distance.

Right: A family of bighorn sheep
wanders the slopes of Mt. Washburn.

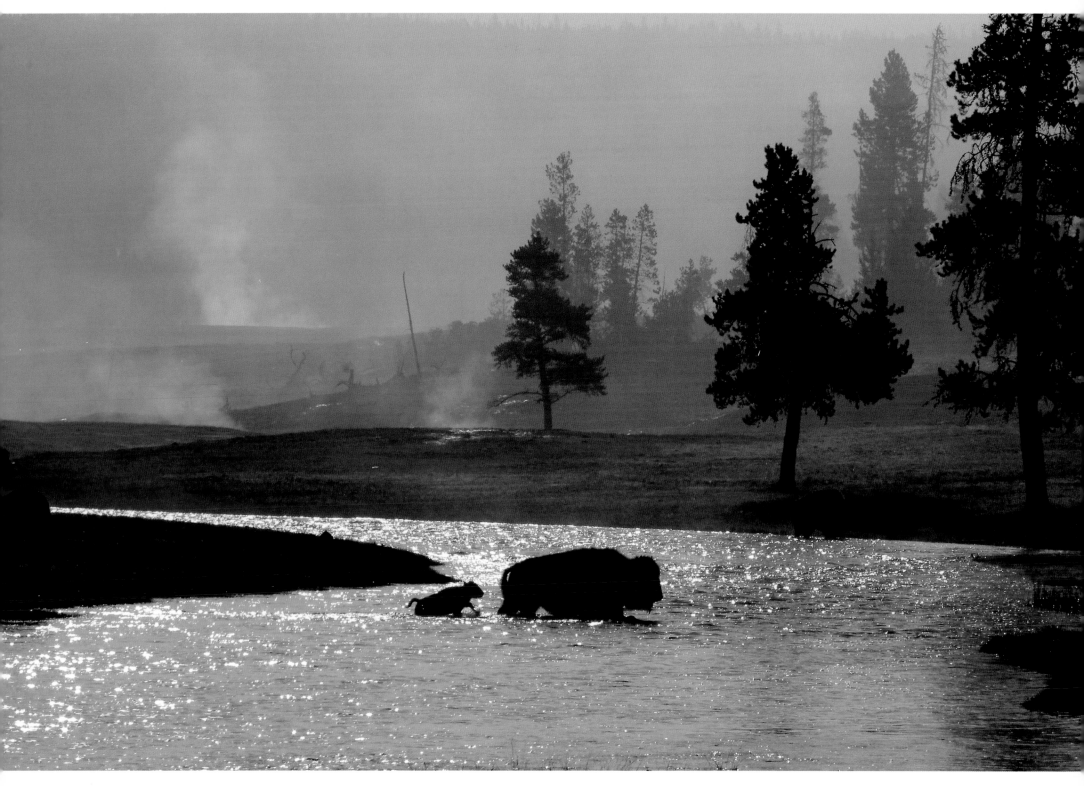

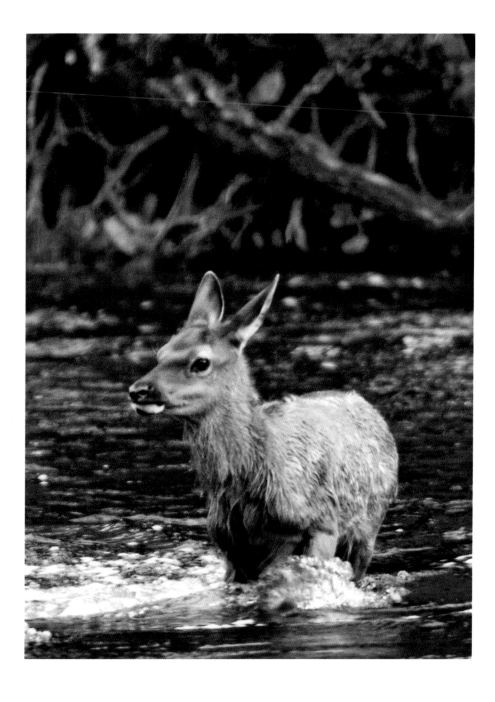

Left: A young elk calved in June splashes through the Madison River.

Far left: Wait up Mom! A bison calf hurries across the Nez Perce Creek. Newborns are up and walking within hours of their birth. Fording creeks, on the other hand, is another story altogether.

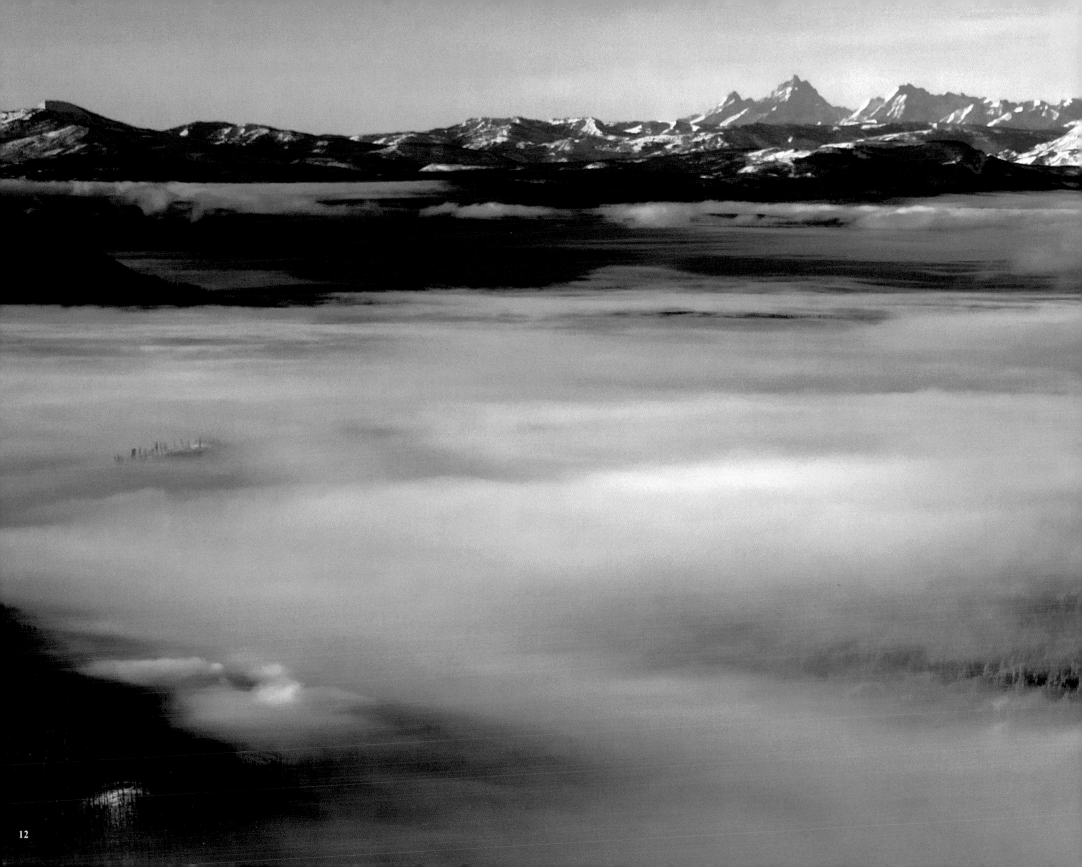

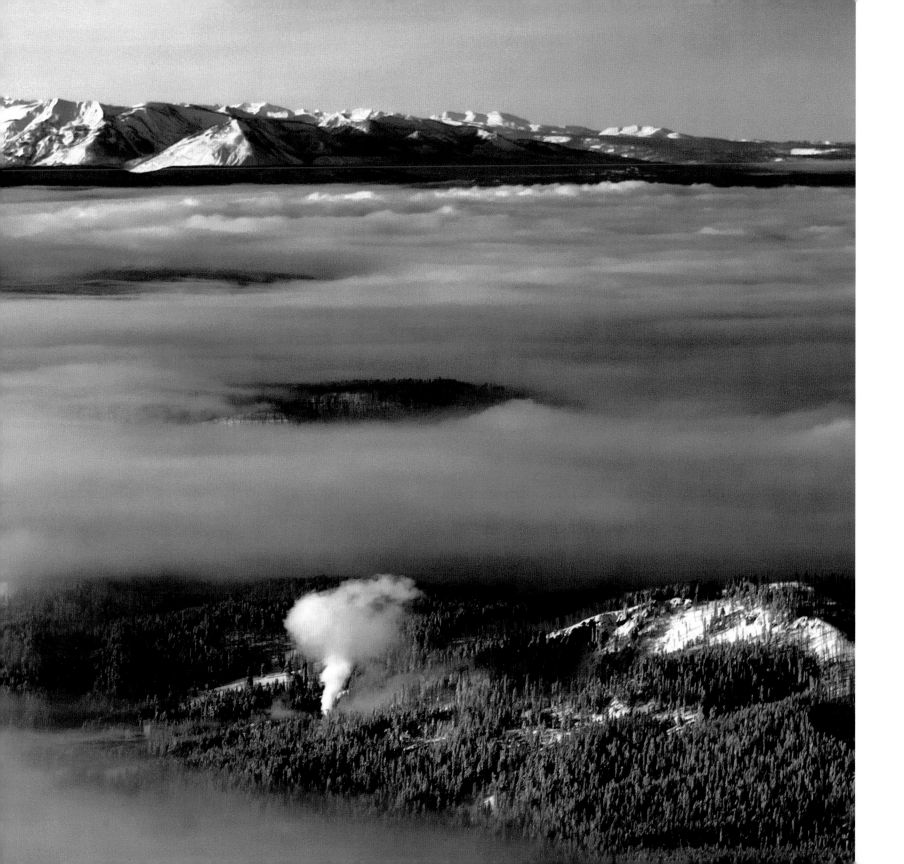

A thick fog blankets Yellowstone Lake in this sweeping north-south view. In the north, a solitary thermal feature churns out clouds of steam; further to the south, the jagged peaks of the Tetons can be seen.

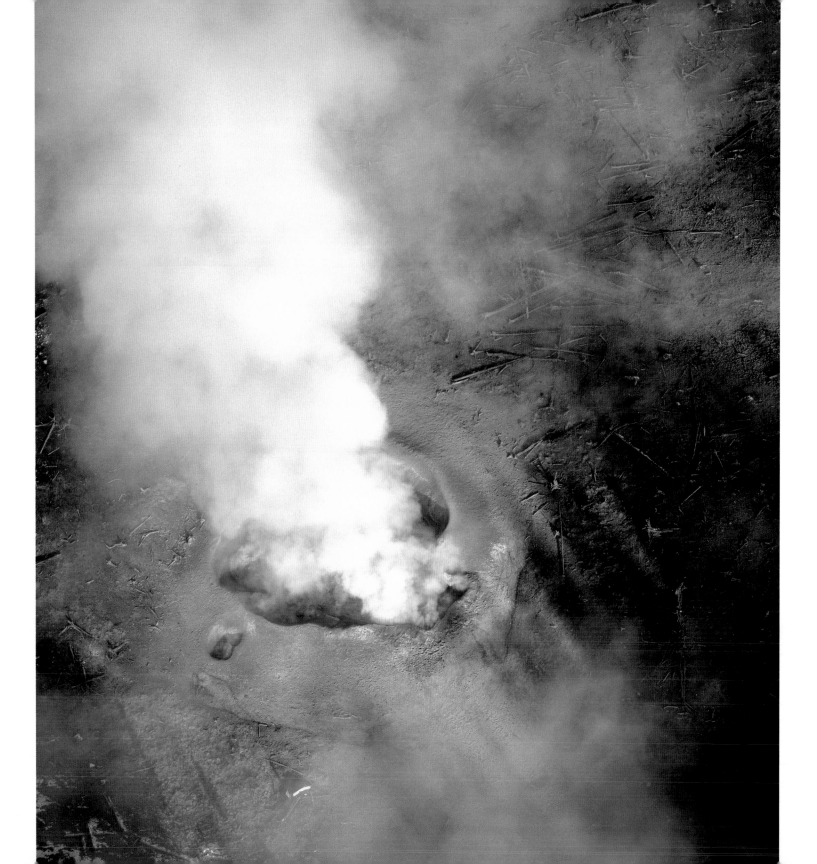

Among the more than 10,000 thermal features in the park, this backcountry mud cauldron is just one of the many reasons one probably shouldn't skydive in Yellowstone.

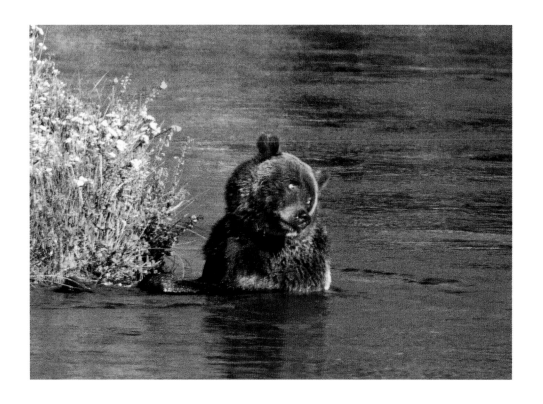

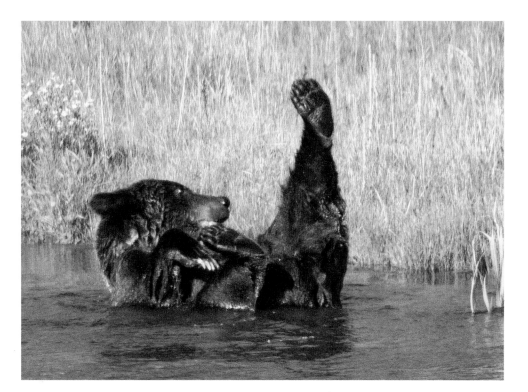

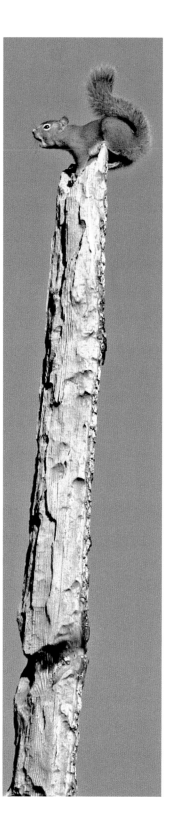

Perhaps another cautionary caption would read, "Never taunt a grizzly," as this squirrel seems to be doing. Keeping a safe distance is always a good idea.

Yellowstone Lake serves as the backdrop
to this early morning scene. At first glance,
the sow grizzly seems to be merely enjoying
a sunrise. But look again.

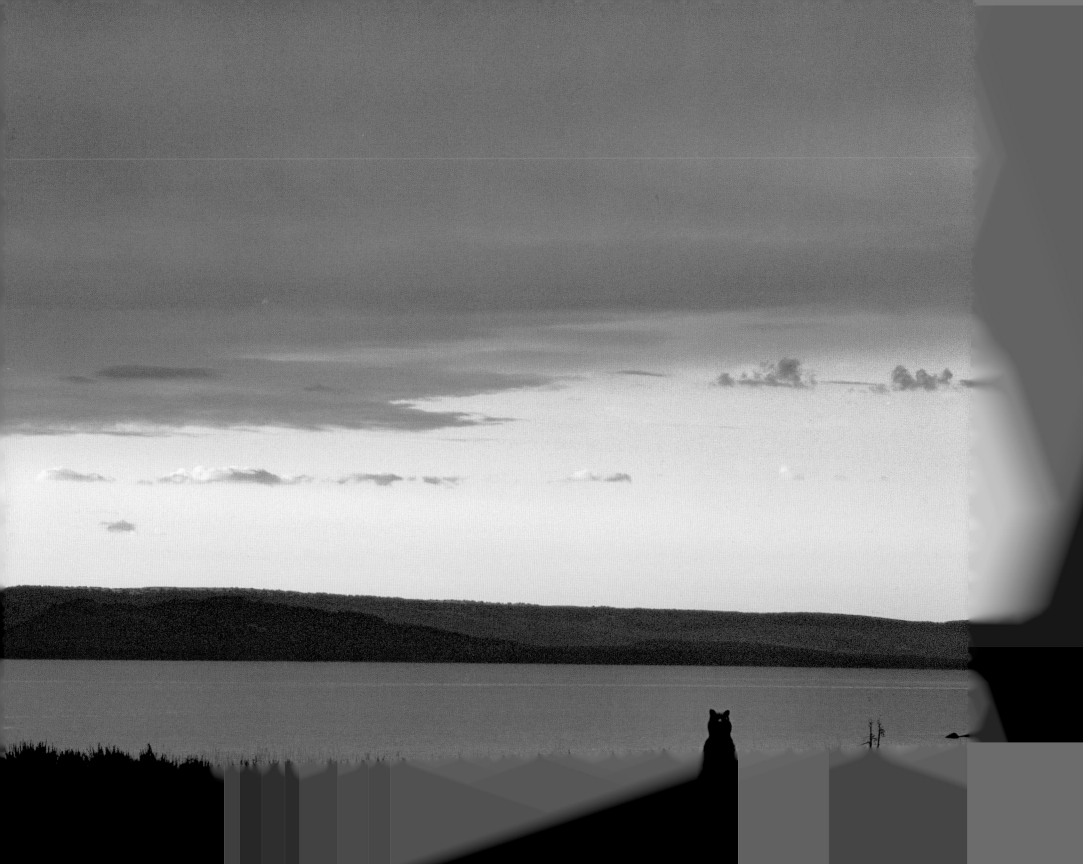

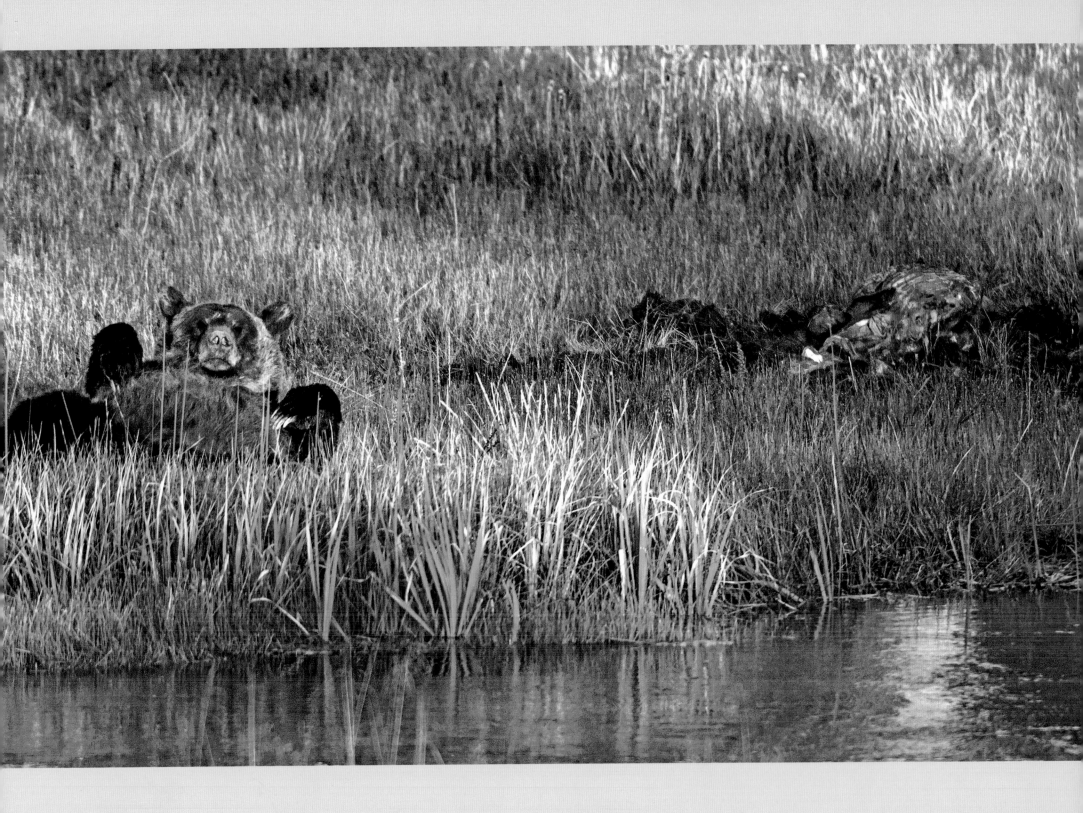

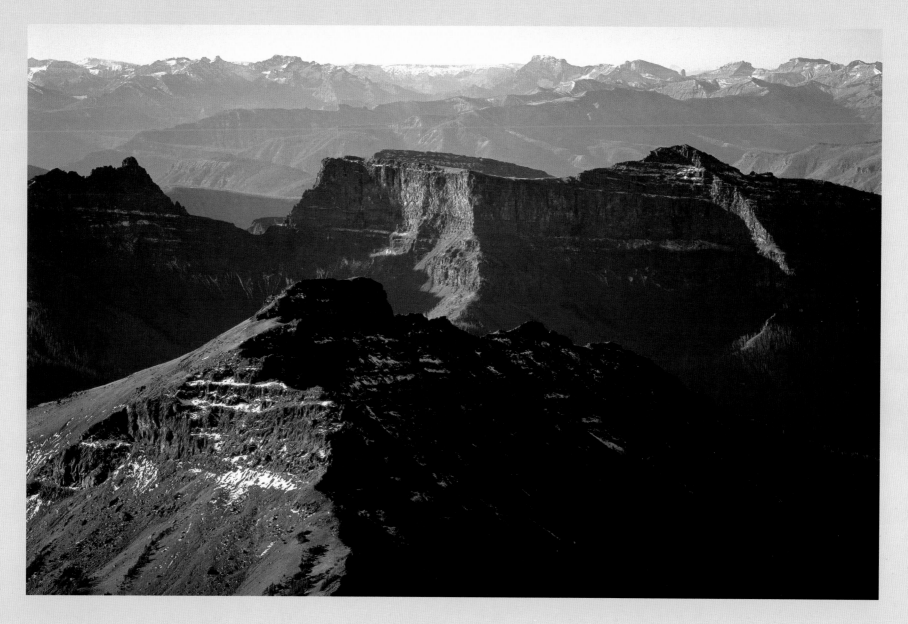

Above: The Absaroka Range provides
prime habitat for grizzlies.

Facing page: *Ursus arctos bellyfullis*,
Latin for "Happy Bear".

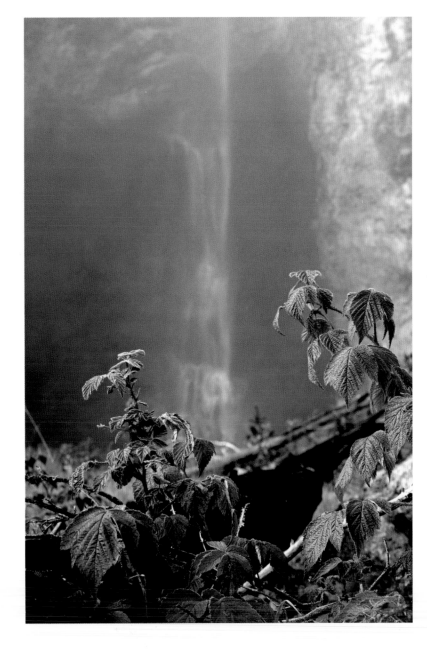

Above: Fairy Falls is a popular hiking destination. And wild raspberries thrive in the perpetual mist of the falls.

Right: Keeping an eye out for predators, an ever vigilant cow elk shields her newborn at the edge of Firehole Canyon.

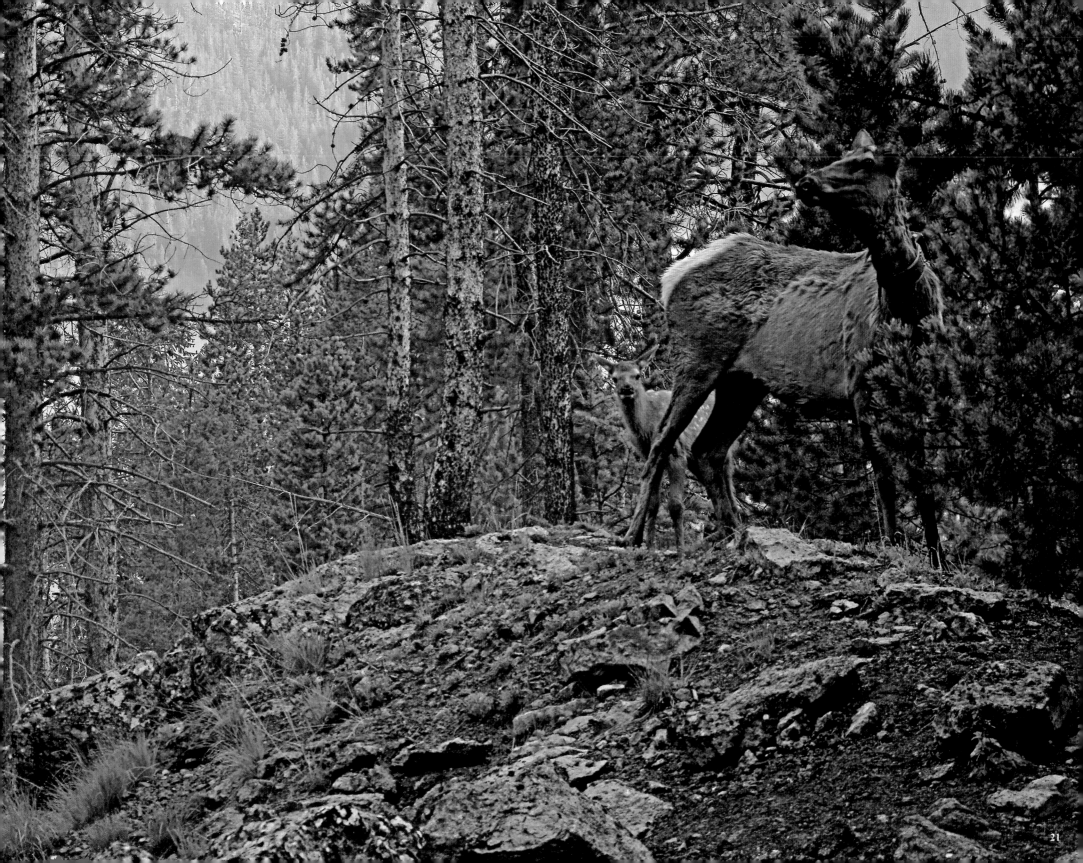

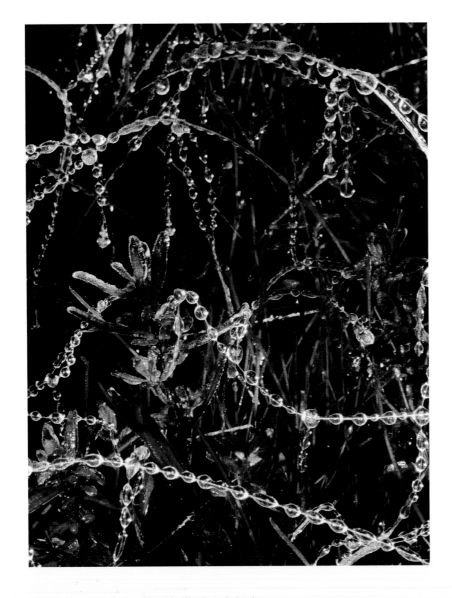

Above: Water droplets sparkle like jewels in the early morning light.

Right: One characteristic of the lodgepole pine is its shallow but wide root system. This particular lodgepole, located by thermal runoff, is slowly becoming mineralized, absorbing silica-laden water into its trunk.

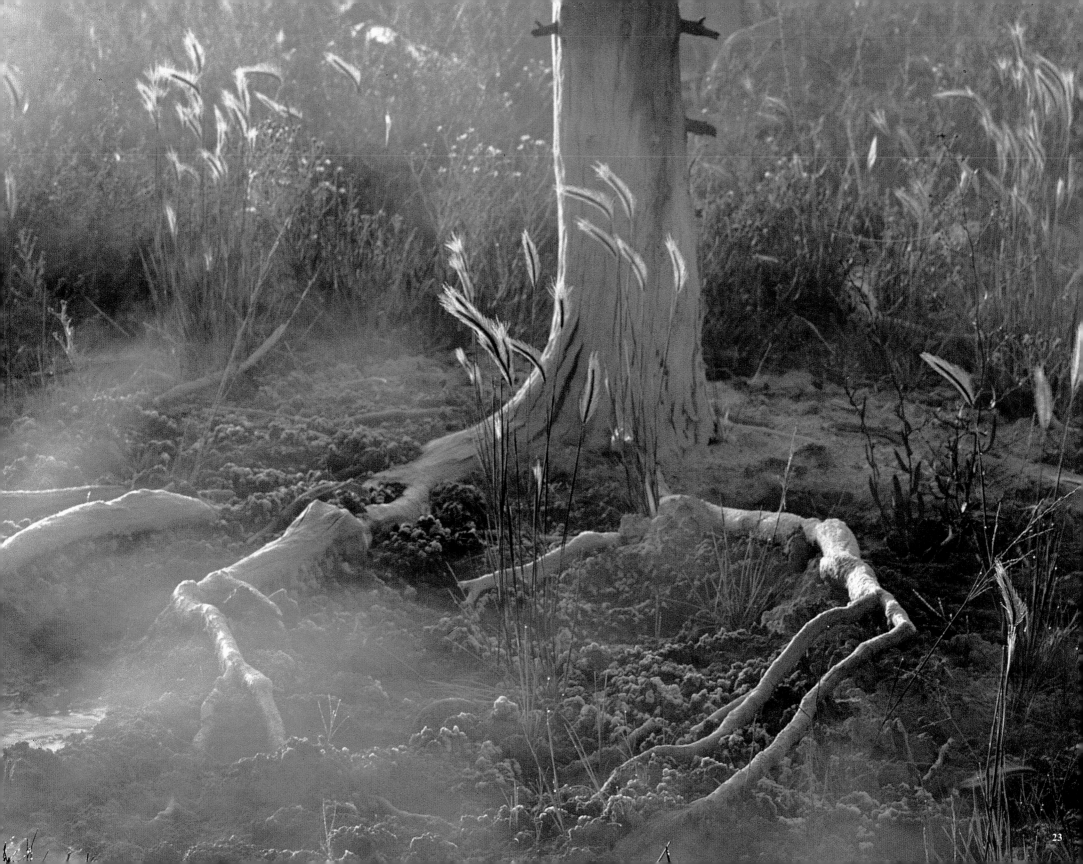

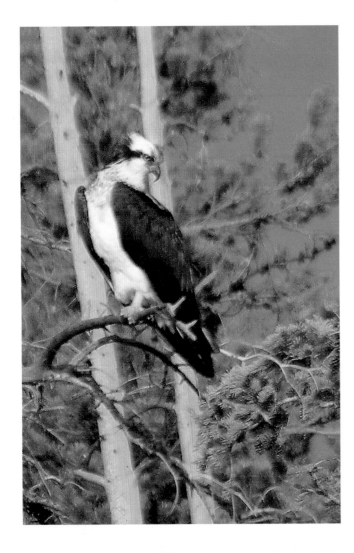

Above: An osprey on the lookout. The Grand Canyon of the Yellowstone, with its many rock spires and its trout-filled river, is an ideal nesting ground for these graceful birds of prey.

Right: Ribbon Lake, the source of Silver Cord Cascade, is located on the South Rim of the canyon.

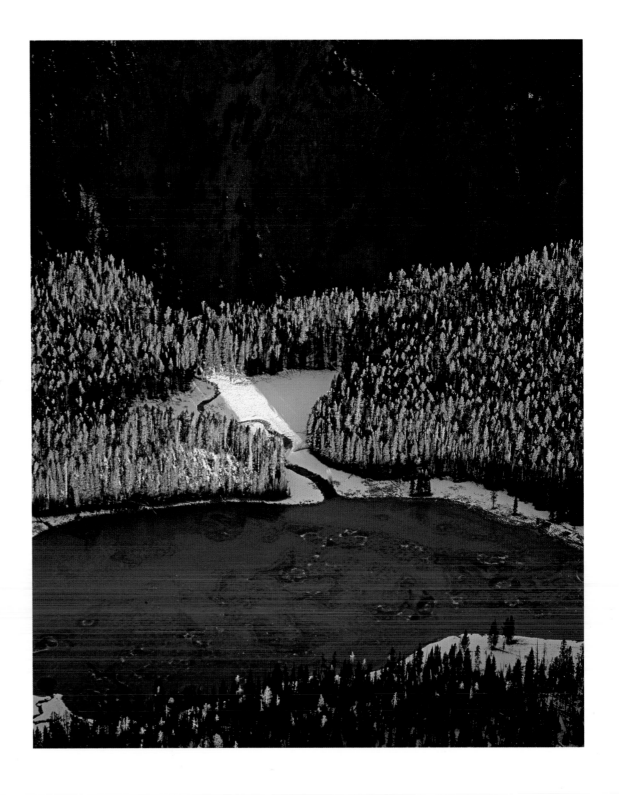

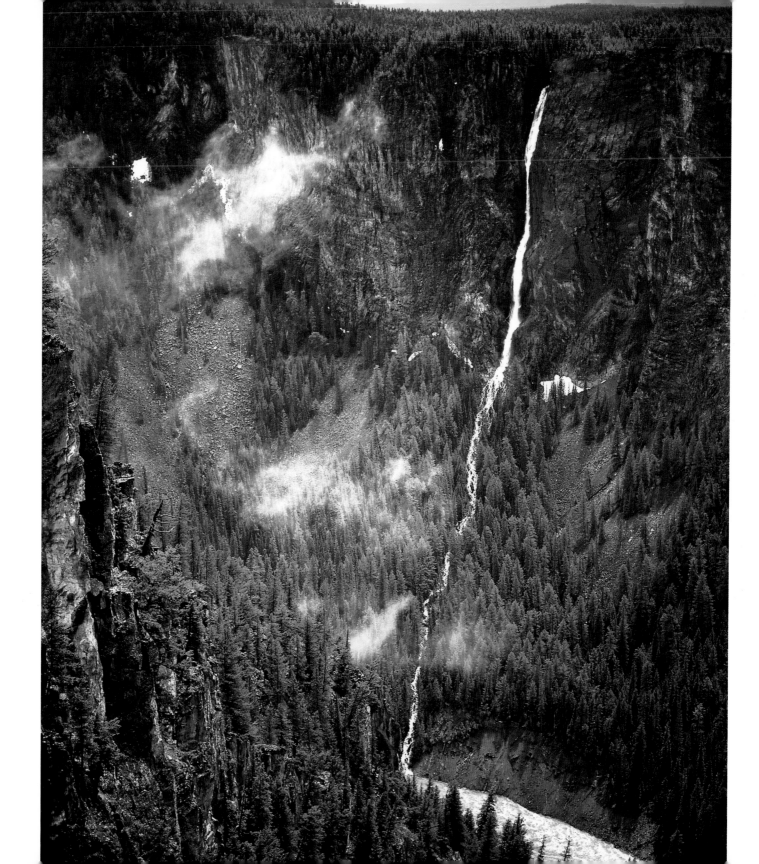

Silver Cord Cascade as seen from the North Rim of the canyon.

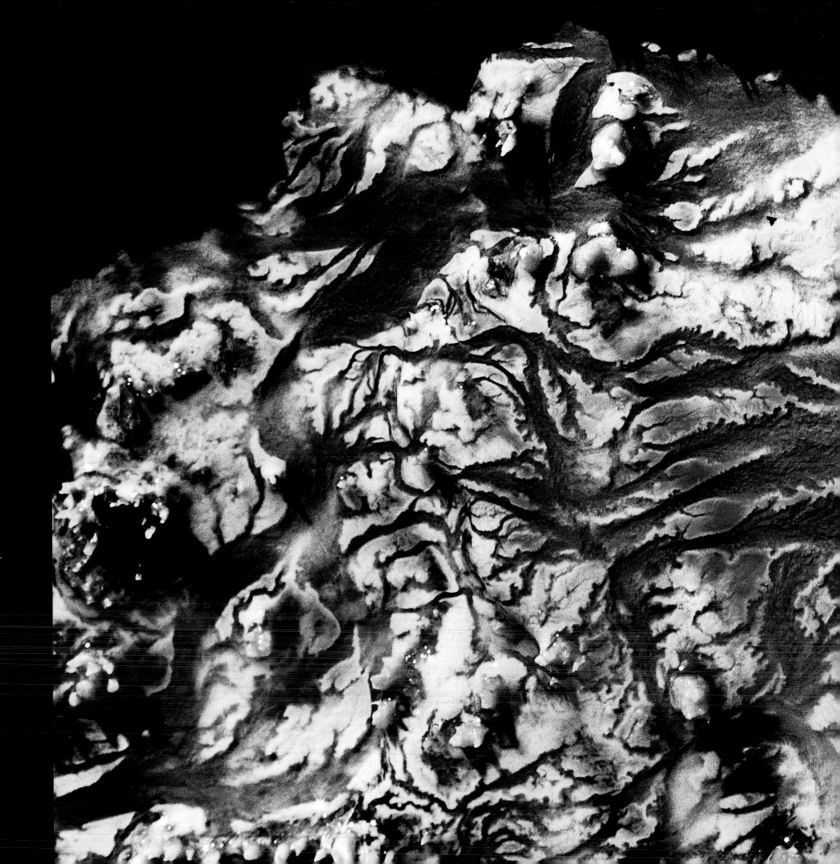

Microorganisms such as cyanobac-
teria are responsible for much of
the brilliant color in and around
Yellowstone's hot springs.

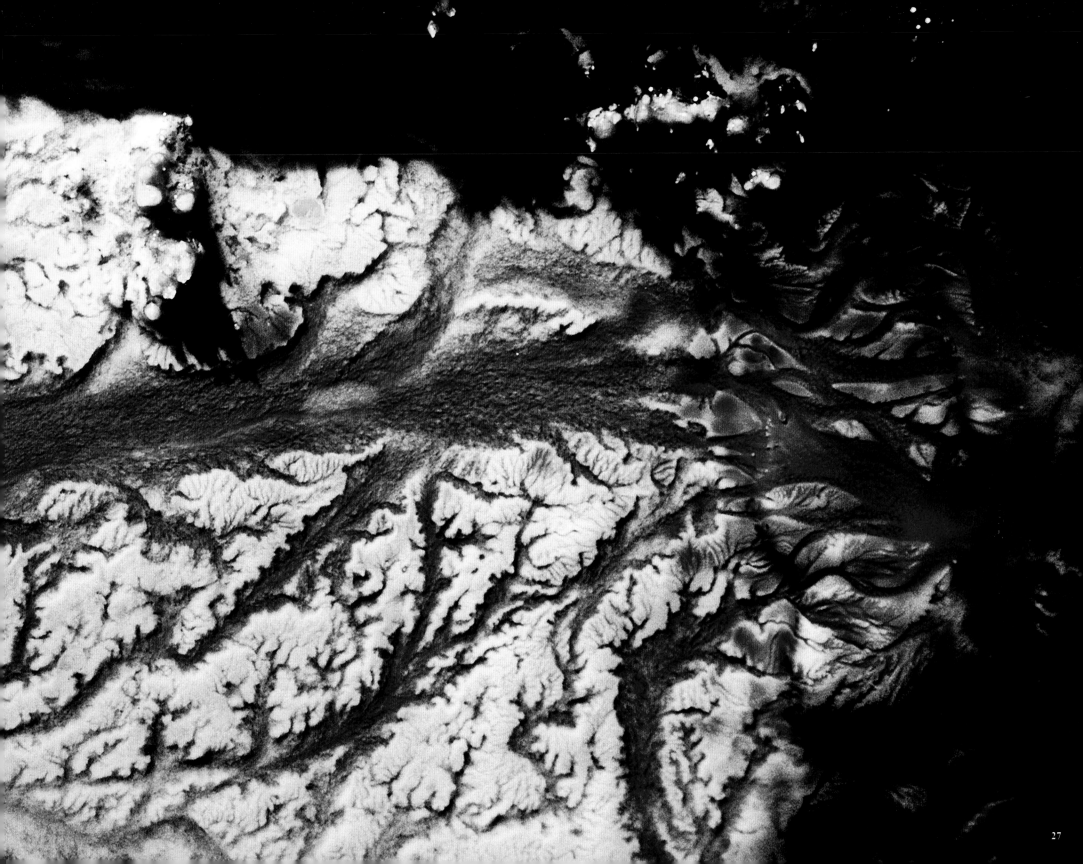

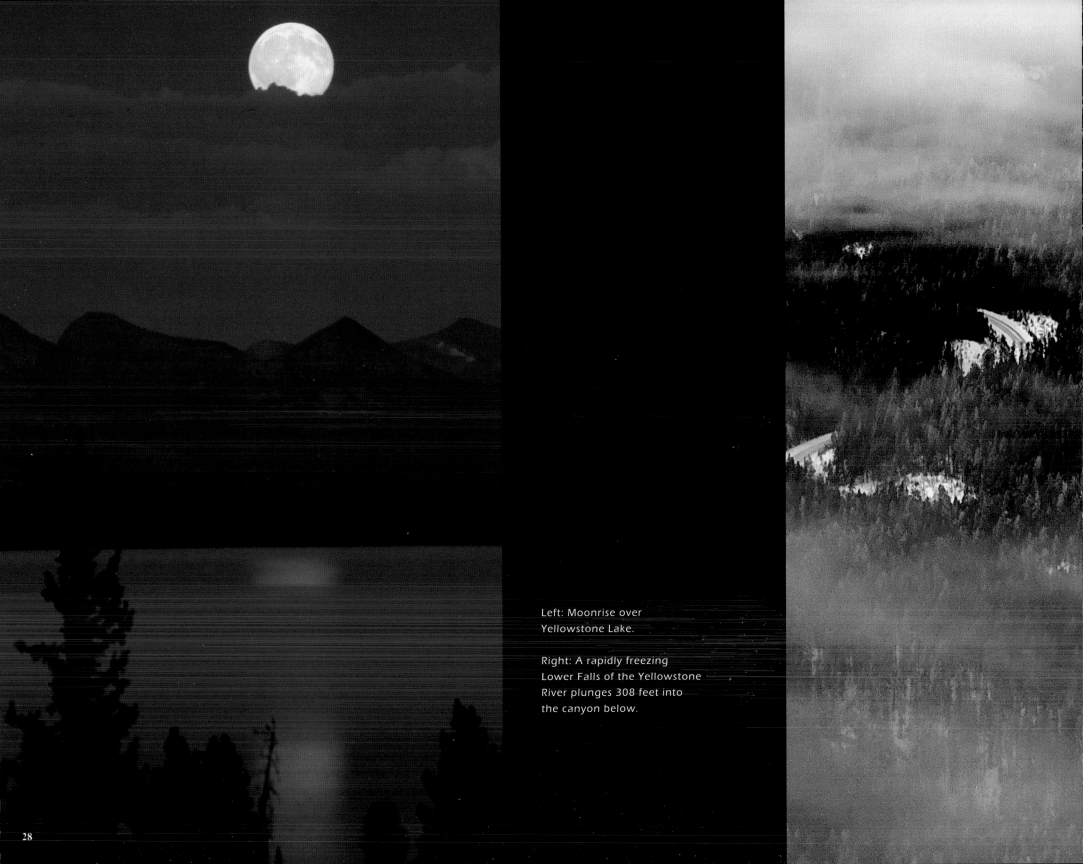

Left: Moonrise over
Yellowstone Lake.

Right: A rapidly freezing
Lower Falls of the Yellowstone
River plunges 308 feet into
the canyon below.

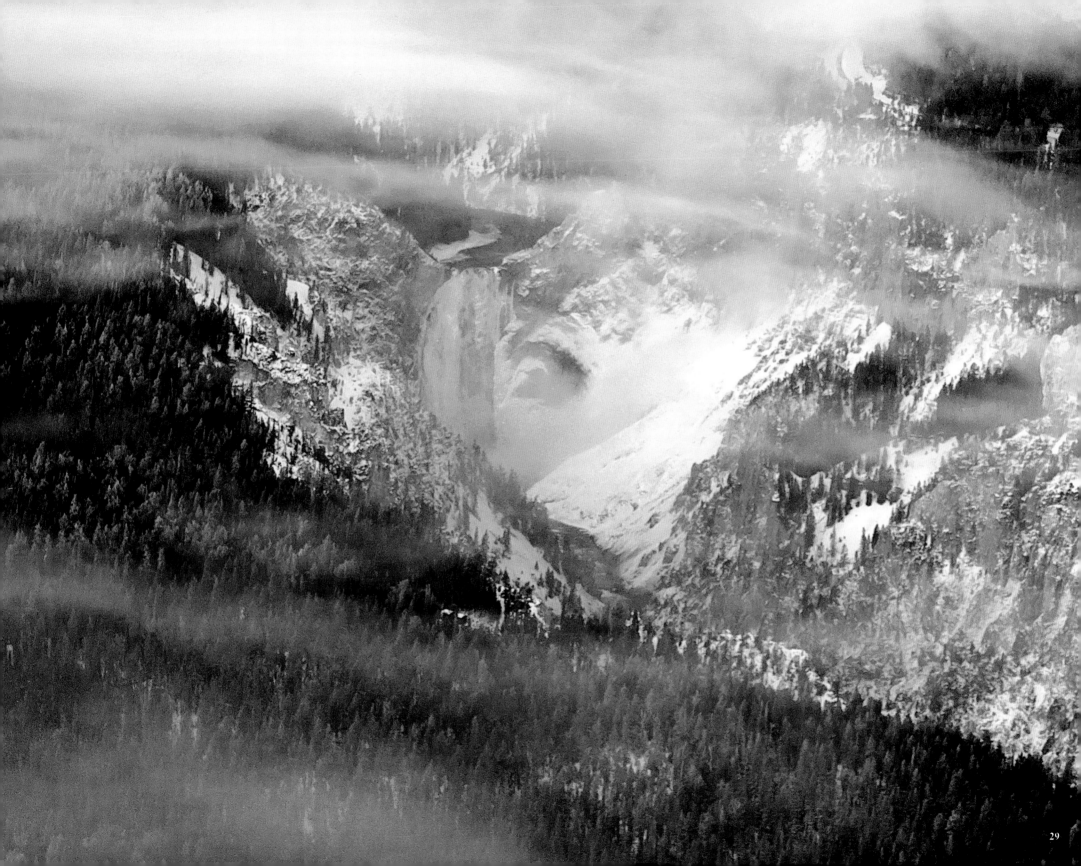

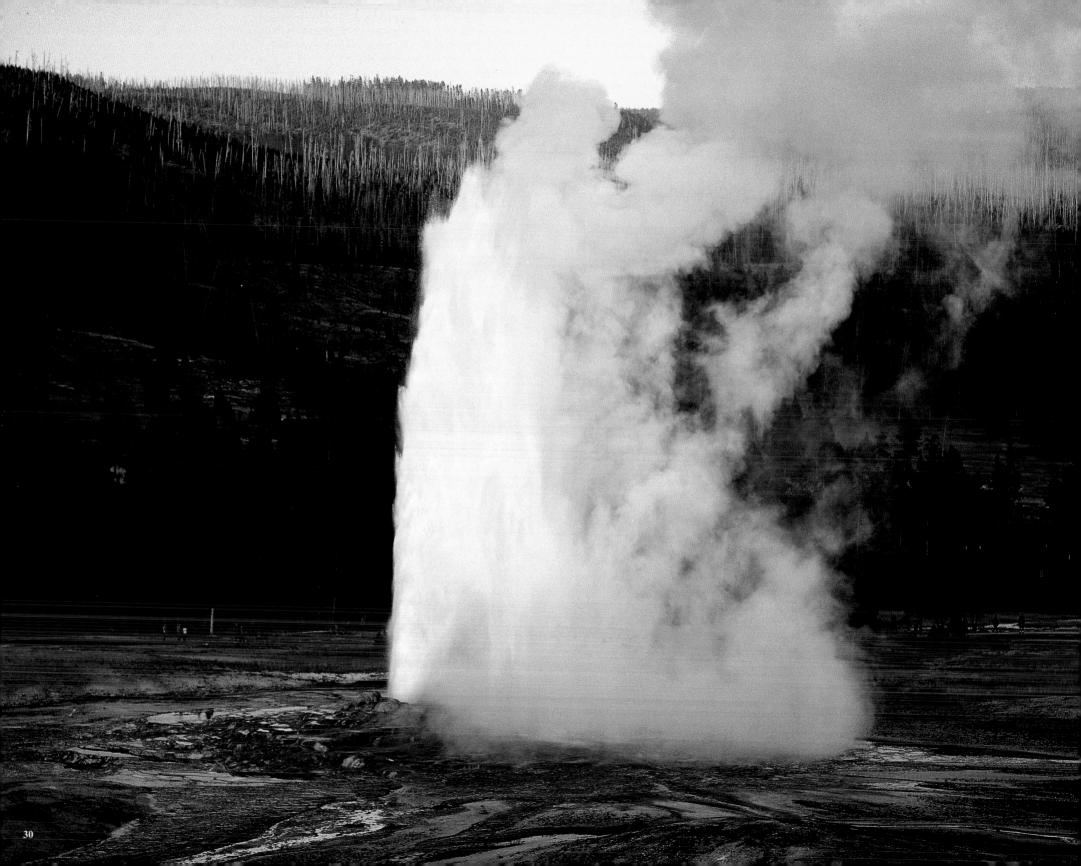

Left: Old Faithful Geyser as seen from the Old Faithful Inn's crow's nest.

Right: Lichens growing on an obsidian boulder.

Below: Twin petrified trees on Specimen Ridge.

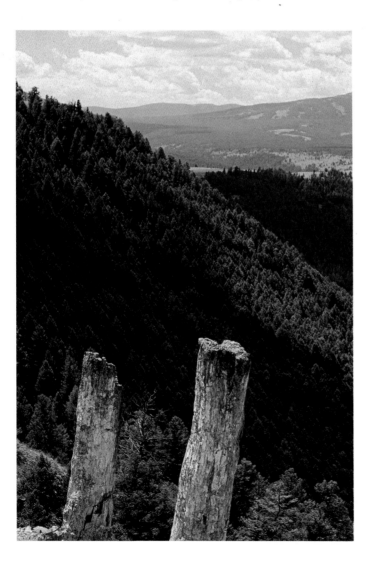

It has been said that Yellowstone was born of dual elements: fire and ice. That said, it was no doubt a long and very eventful delivery. Petrified wood, such as the two pines pictured here, came about after whole forests were buried 45 to 50 million years ago by multiple volcanic eruptions. The trees, still upright, then turned to stone before eventually becoming unearthed by centuries of erosion.

Obsidian, or black volcanic glass, forms when molten lava cools rapidly. The half-mile long Obsidian Cliff, where the above sample was photographed, is thought to have formed when magma surfaced and immediately came into contact with a glacier.

Old Faithful, the world's most famous geyser (facing page), emits superheated water up to 185 feet high, a vivid reminder of Yellowstone's geologic past.

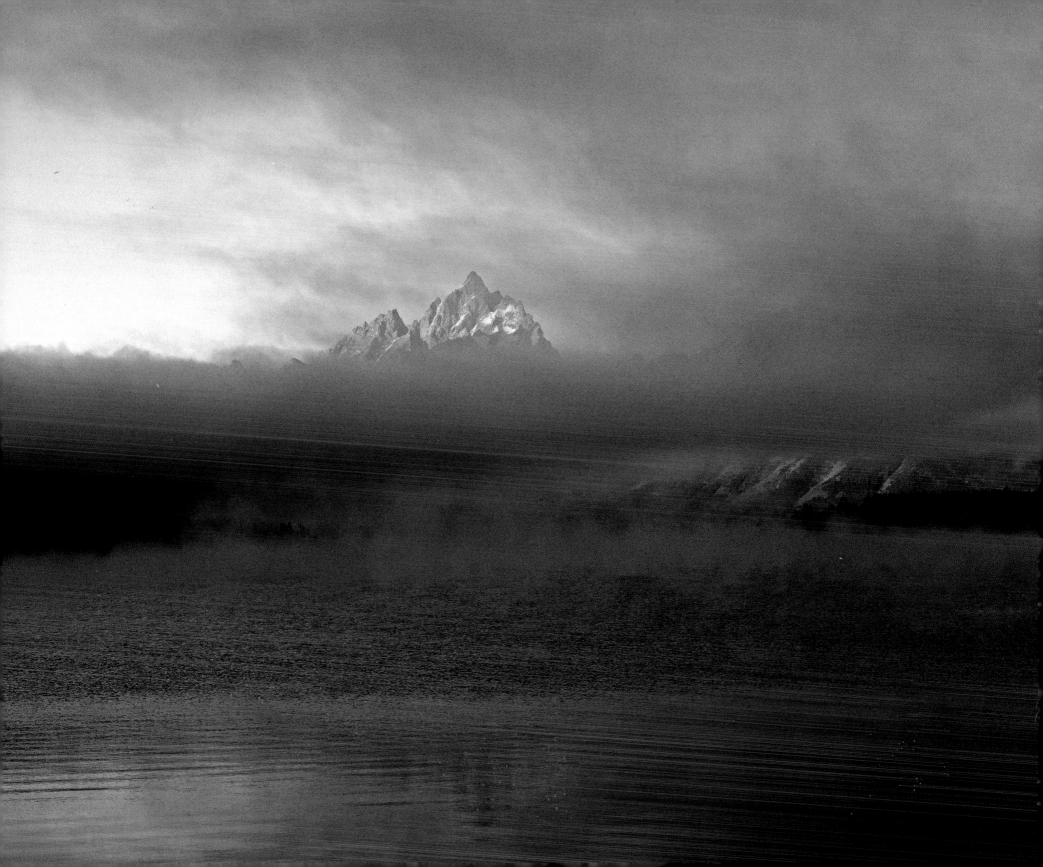

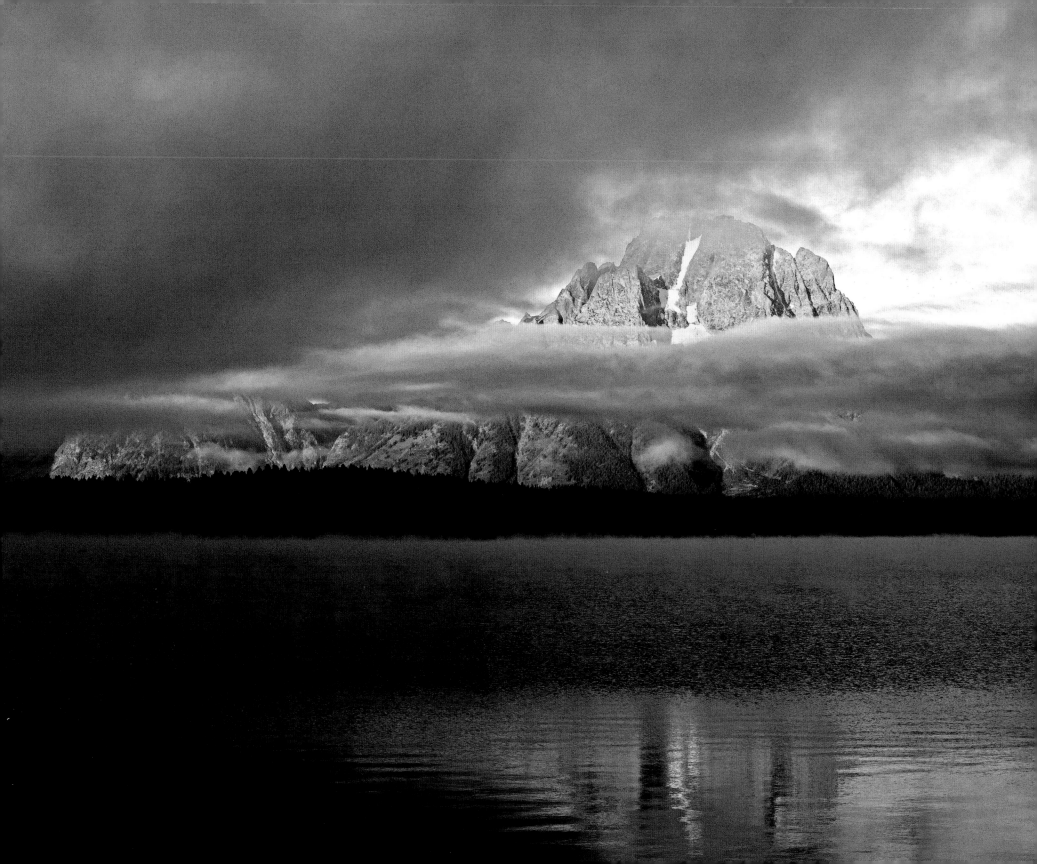

Preceding pages: The Tetons tower majesti-
cally above Jackson Lake.

Right: A hot spring in Shoshone Geyser Basin.

Facing page: Steam and fog commingle some-
where in the rugged Bechler backcountry.

Below: Wyoming Paintbrush.

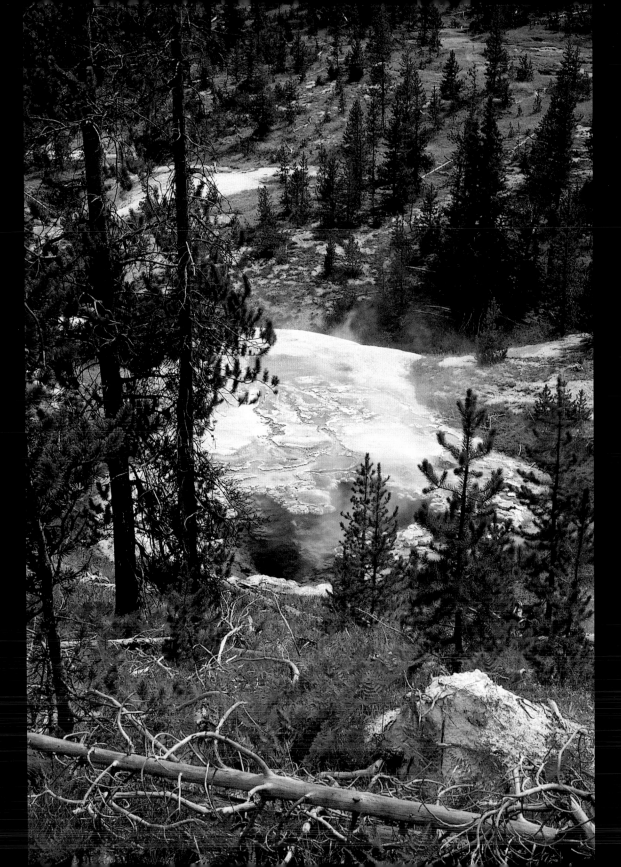

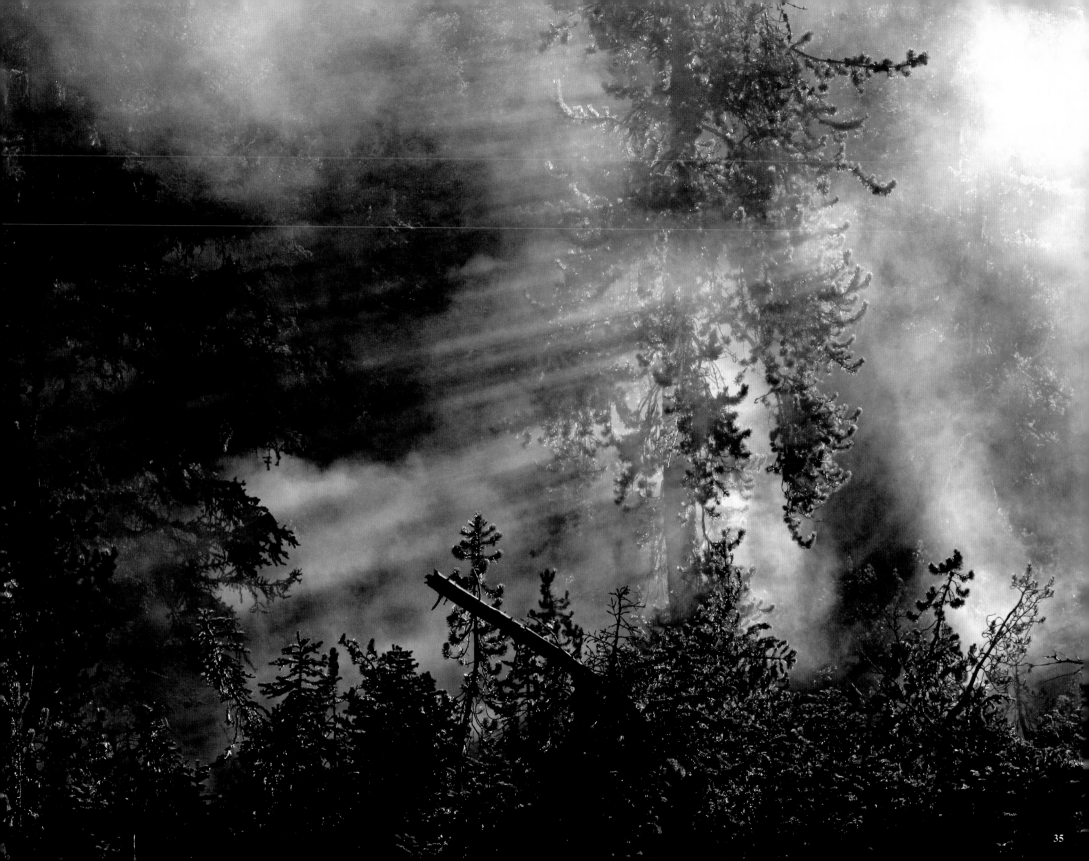

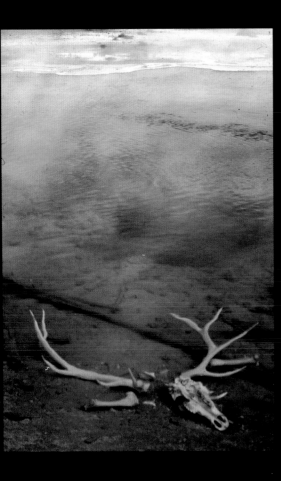

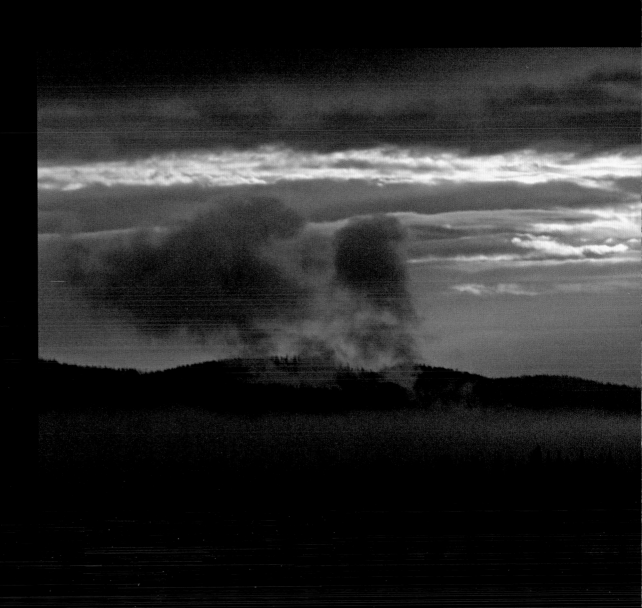

Above: Elk and bison are attracted to the warmth
of thermal features, which can result in mishaps
and scenes like this one at Heart Lake Geyser Basin.

Right: A bull elk in velvet roams the north end
of Yellowstone Lake at daybreak. Sulfur Hills with
their myriad fumaroles loom in the distance.

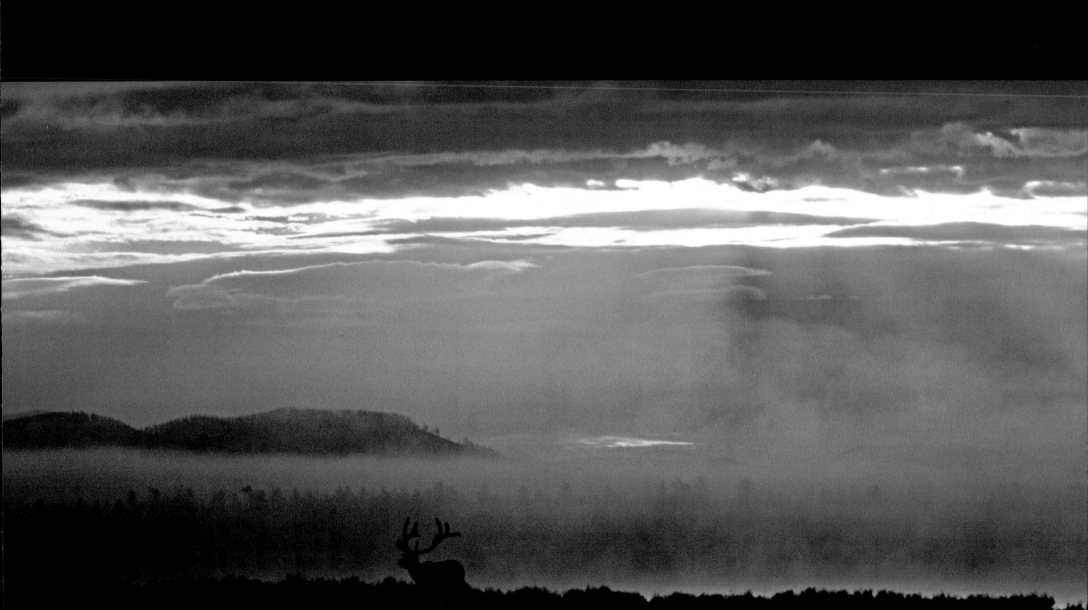

Left: A silhouetted
Lone Pine Geyser
erupts as the sun rises
over Yellowstone Lake.

Facing page: A young
cow elk poses in West
Thumb Geyser Basin.

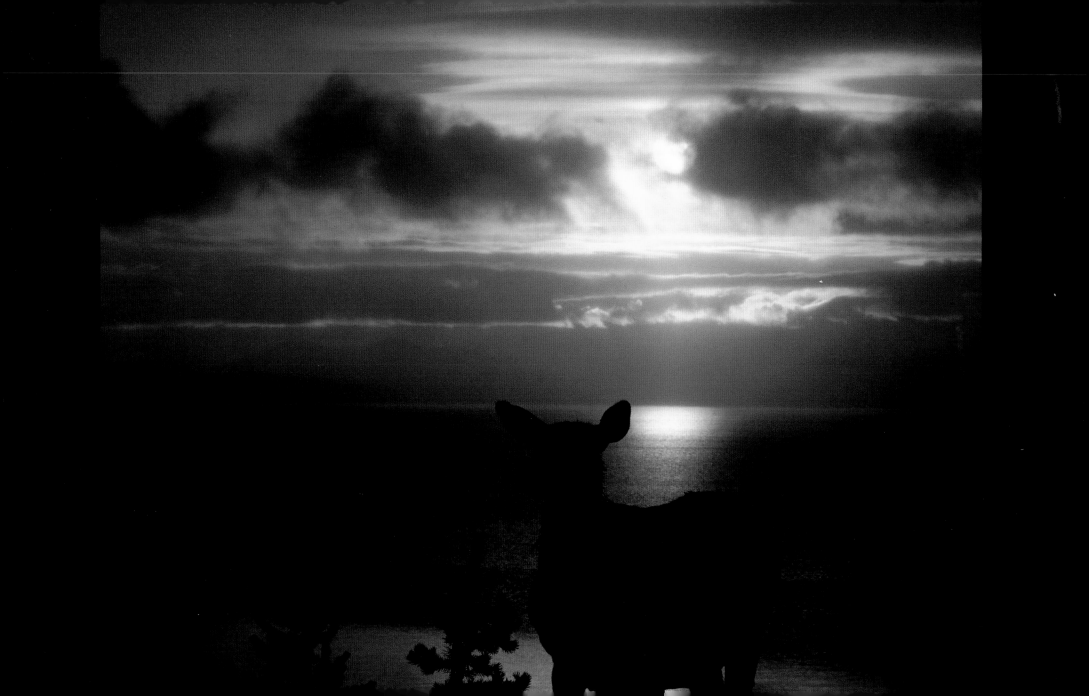

These two pages typify the park in a fairly non-typical way. Most visitors, for instance, will see Yellowstone's canyon and falls, but not necessarily from this particular osprey's-eye-view (facing page). And quite a few people these days see bear. Rarely, however, do they see bear *seeing* bison (below). The bison pictured to the right don't seem to notice Old Faithful erupting in the background, nor do they probably care.

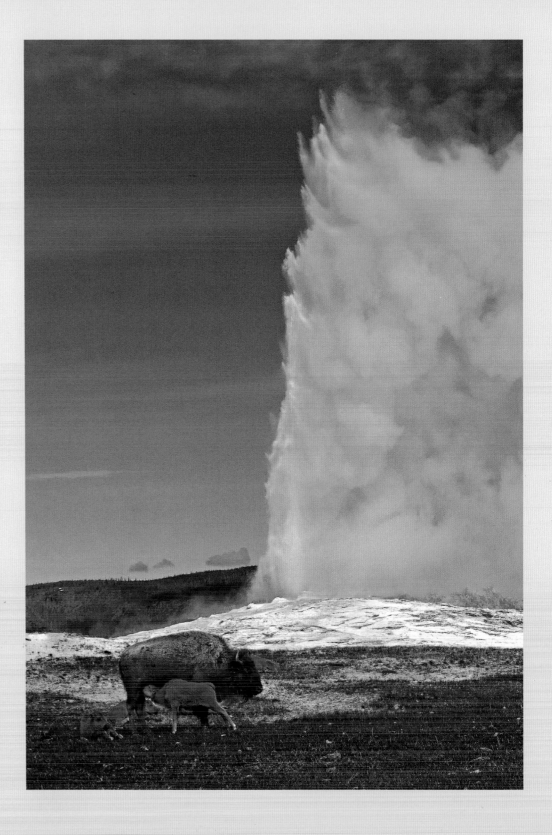

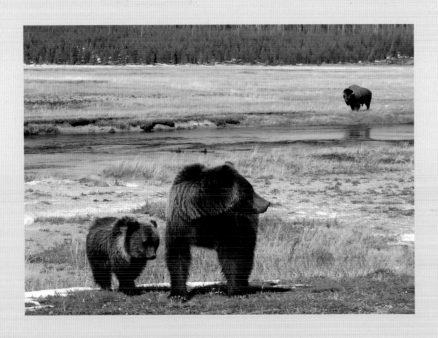

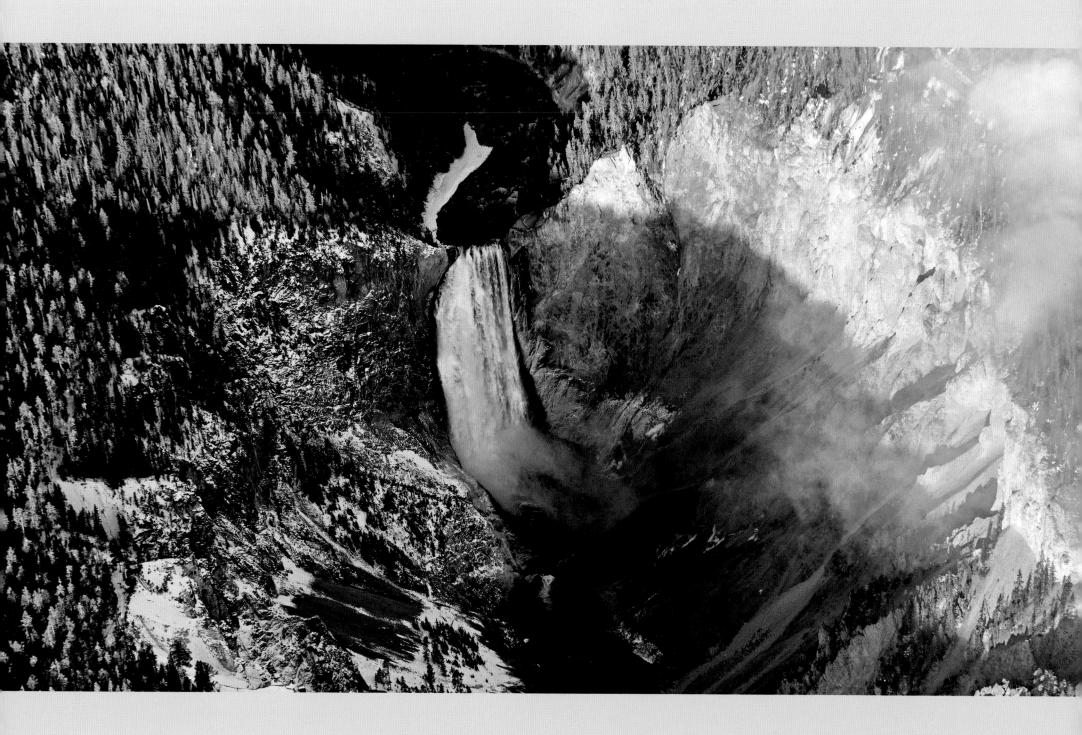

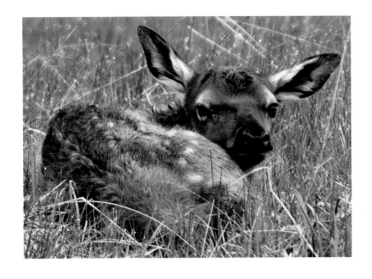

Left and below: This day-old elk didn't stray far from Mom's watchful eyes. After all, predators, like the wolf are never far away.

Facing page: Canary Spring. Travertine limestone formations like this one are some of Yellowstone's more changeable features. Whole trees are often engulfed.

Following pages: Yellowstone Lake Harem.

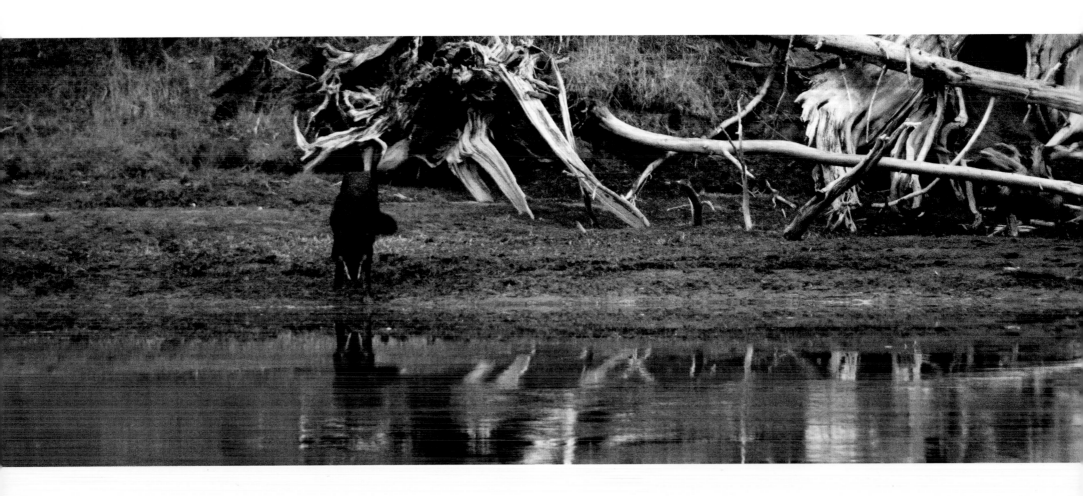

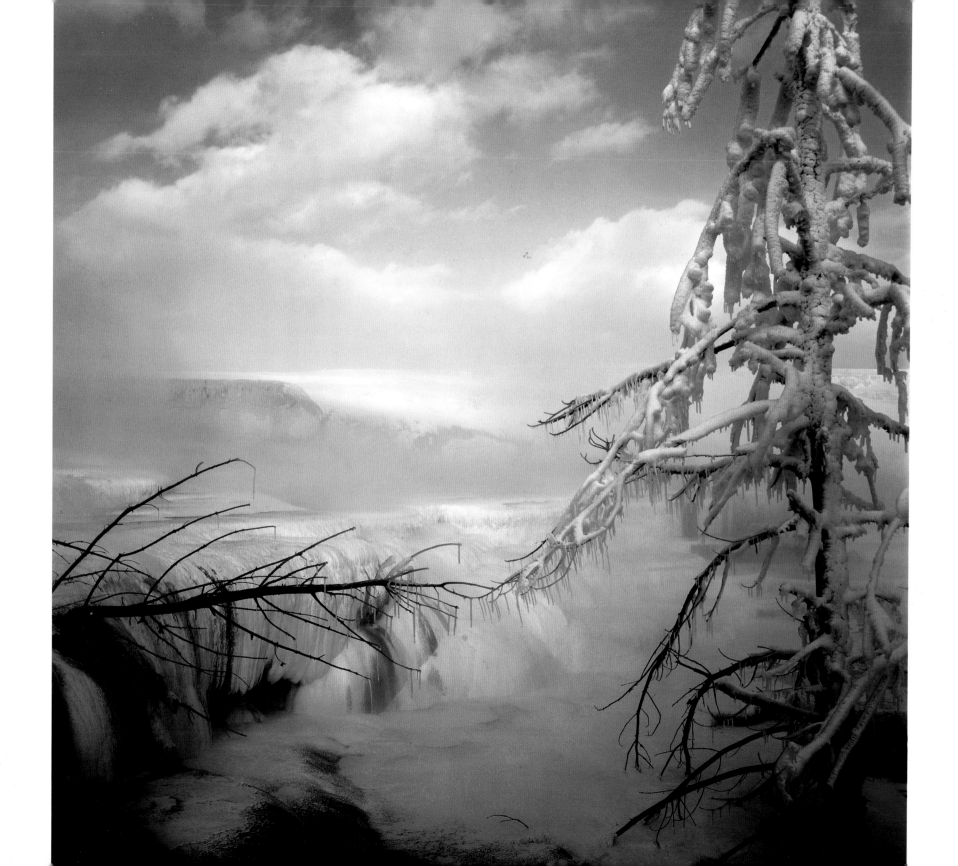

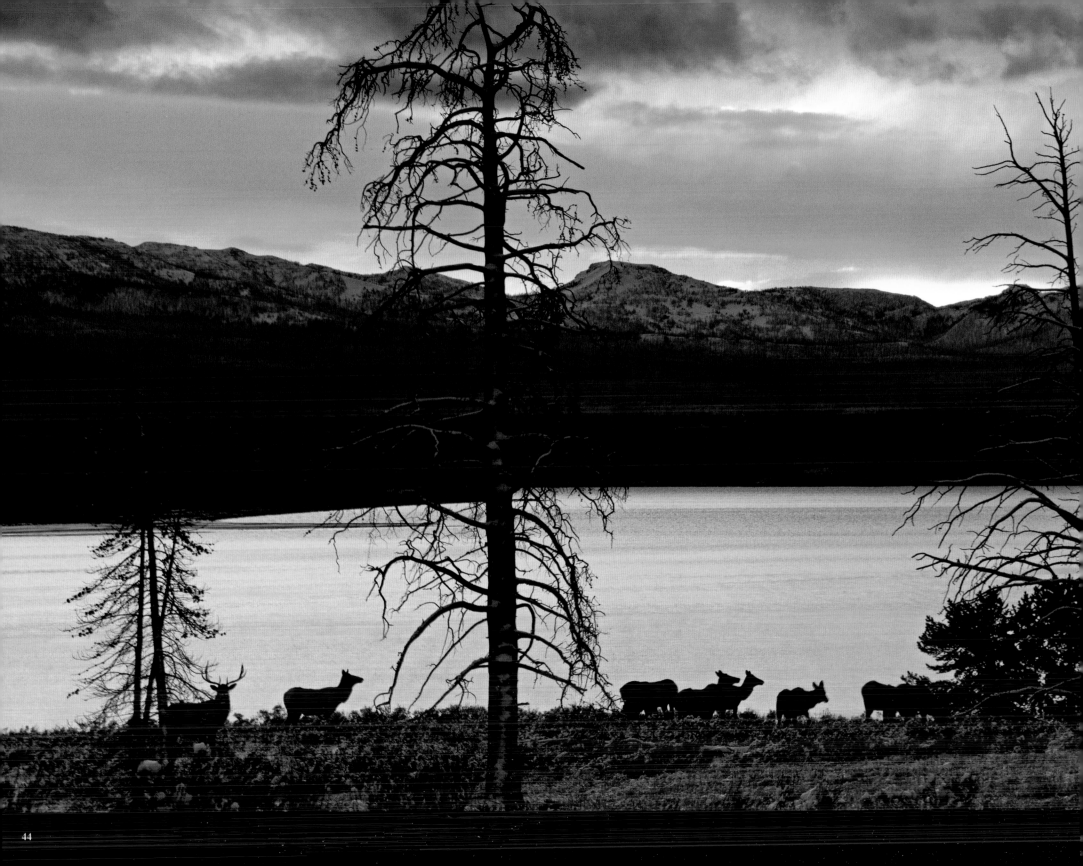

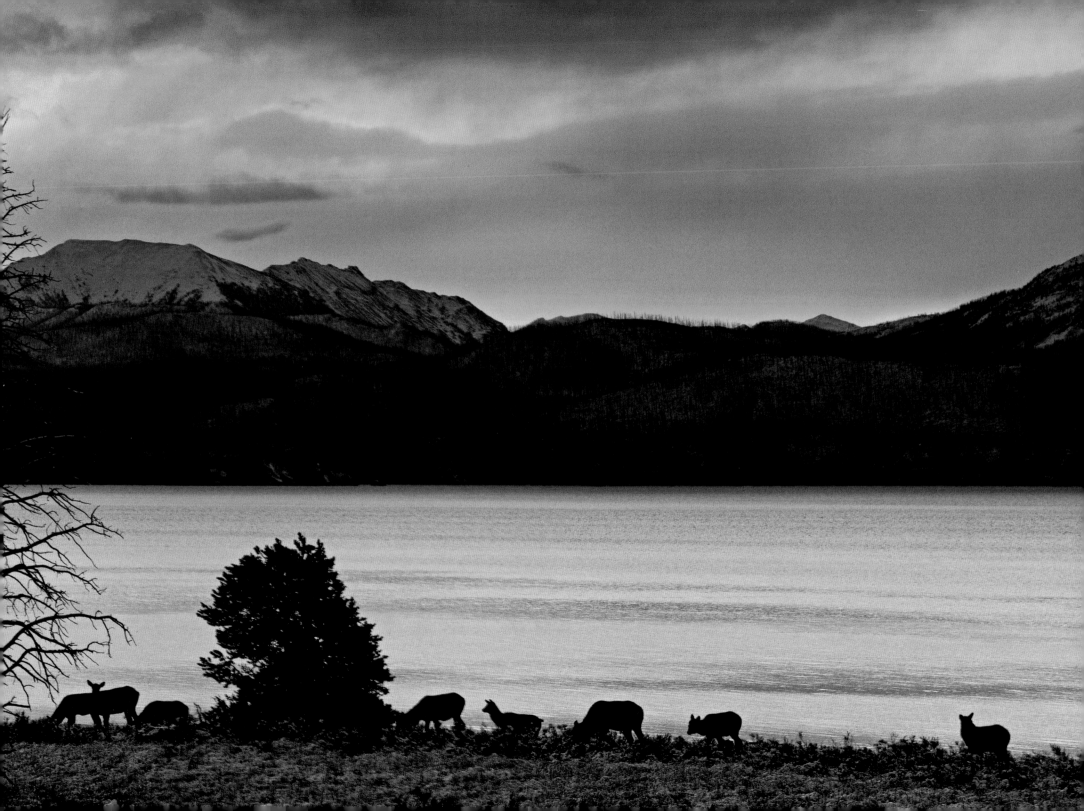

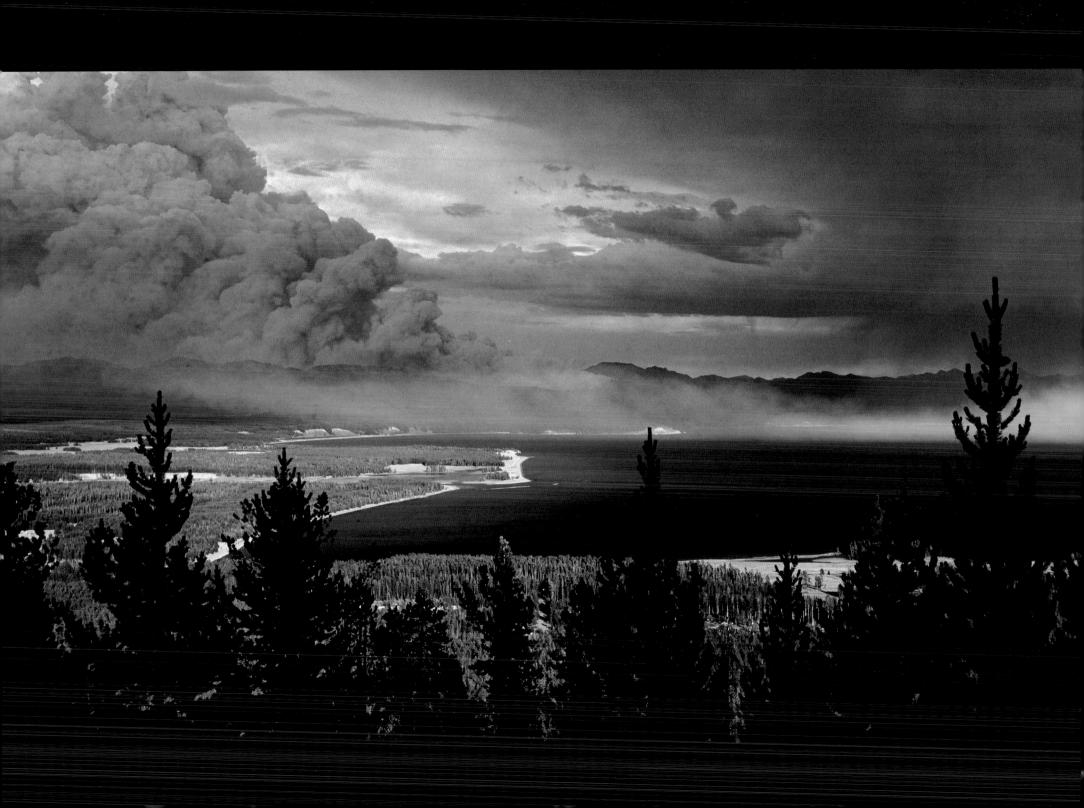

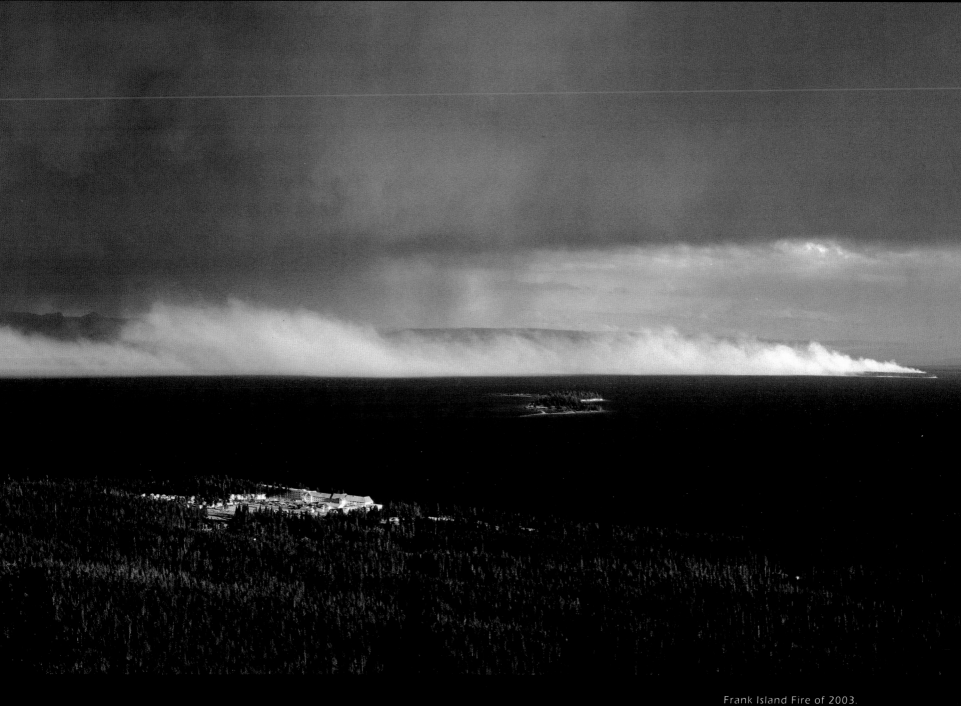

Frank Island Fire of 2003.

Wildfires are an annual occurrence in Yellowstone. More often than not, though, they'll be located deep in the backcountry, and sometimes the only evidence the casual park visitor will have of a fire is a late afternoon haze. When fires do start closer to populated areas, they're more closely managed. In some cases, as in the lightning-caused fire on Frank Island (preceding pages), where there's no chance of them spreading, they're left to burn out naturally.

Lodgepole pine forests are in some cases even dependent on fire to survive. The adapted cones of such trees remain sealed by a resin until the heat of a fire is sufficient to crack them open. An intensely hot fire will not only crack open serotinous cones, but rocks as well (below), and in some cases even large boulders. A fire that hot might not be extinguished until the first snowfall of the year.

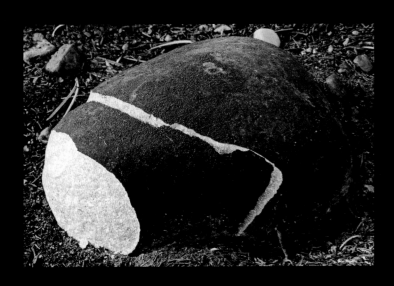

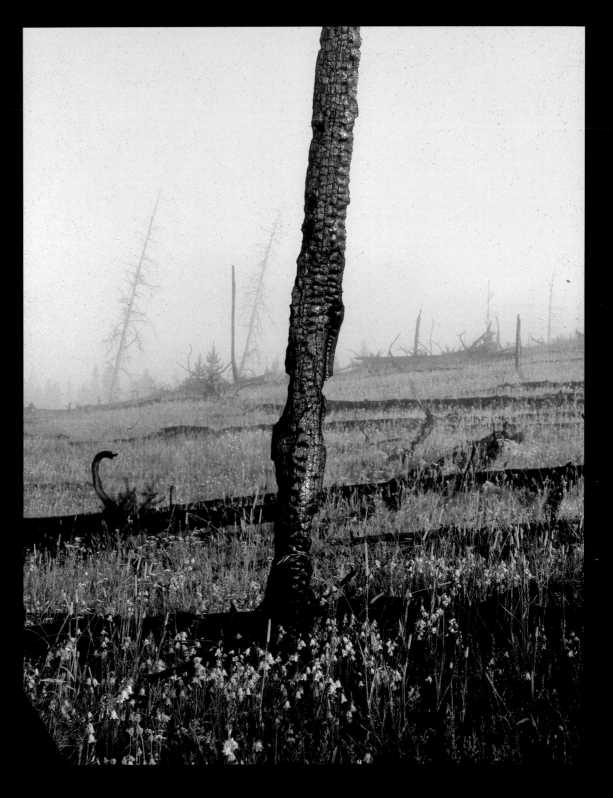

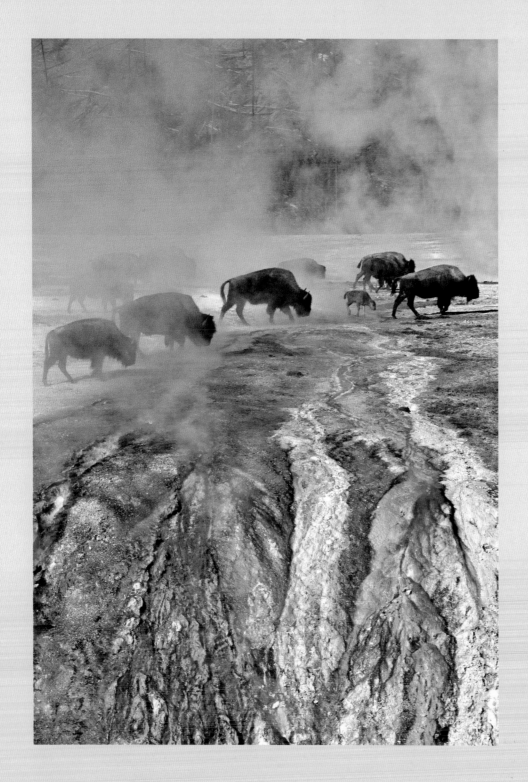

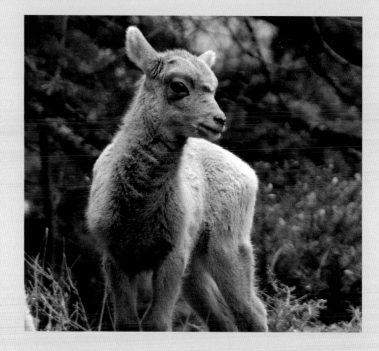

Above: A bighorn lamb strays from the herd.

Left: Algae and bacteria combine to form colorful runoff channels—this particular runoff coming from Excelsior Geyser. But bison don't care. They just have places to go.

Facing page: Gathering down by the river a "baptism of elk" can be heard.

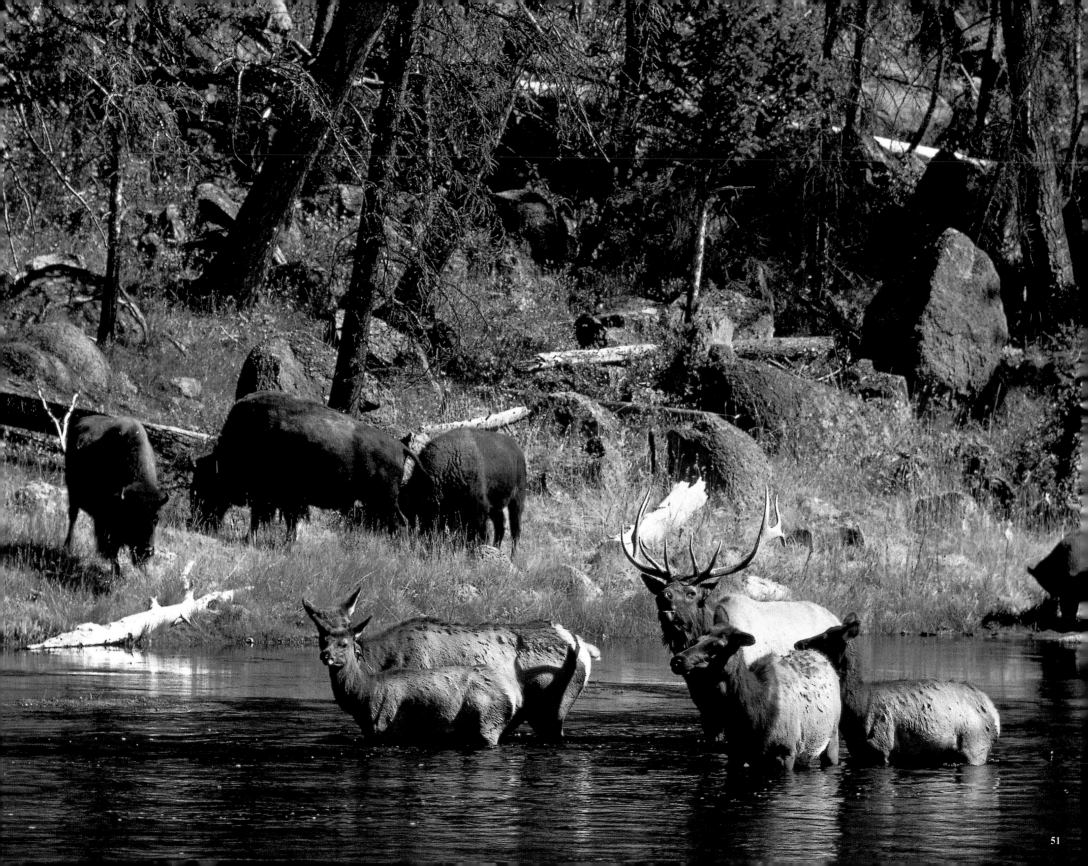

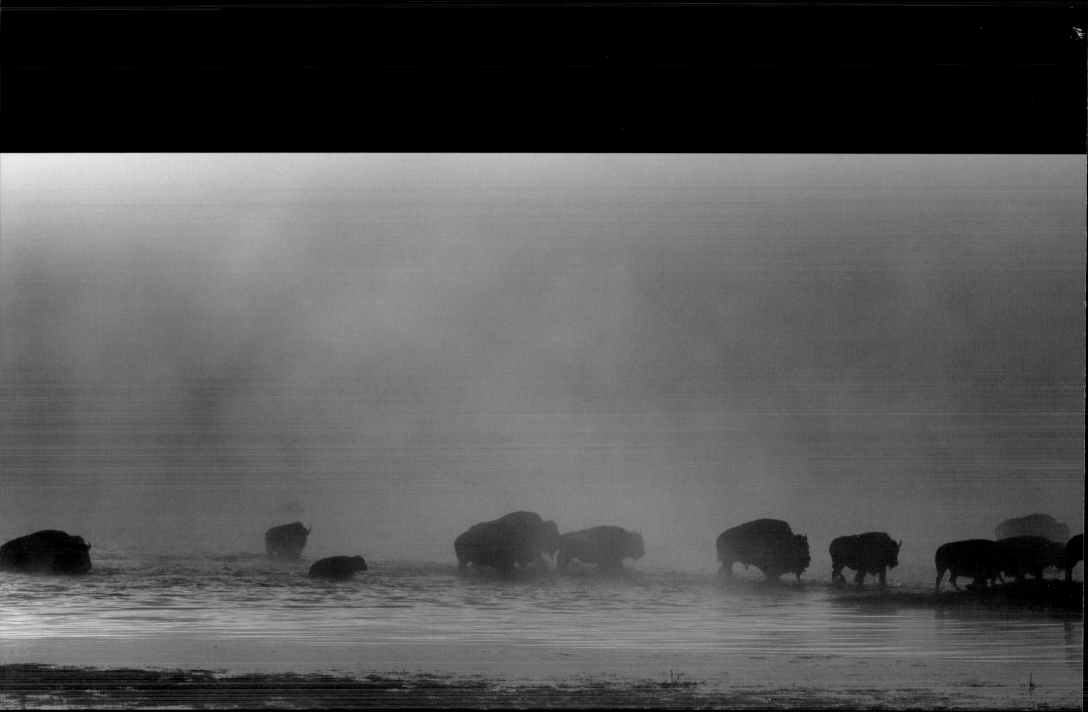

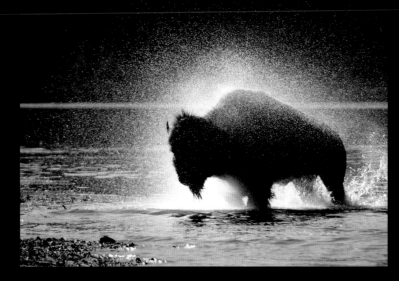

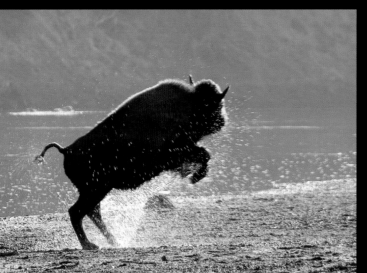

Always on the move, a bison herd crosses the Yellowstone River. Yellowstone Park is the only place where wild bison have lived continuously since primitive times.

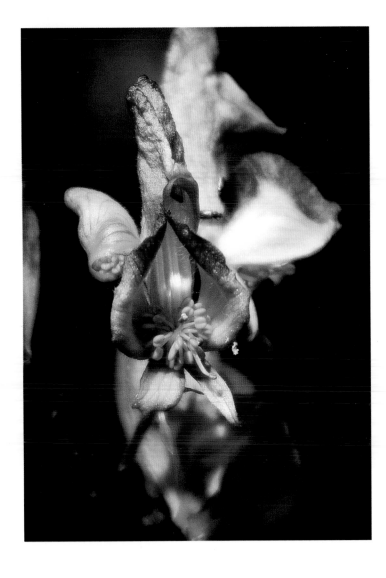

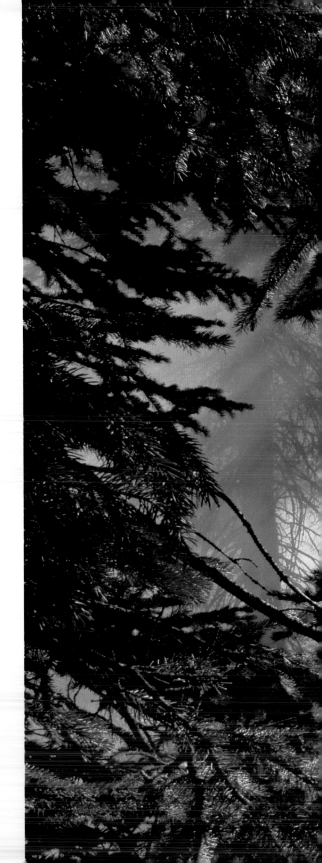

Left: The Western Monkshood was named for its petals' resemblance to the hood on a monk's robe. It can be found growing in moist woods (facing page) and subalpine meadows.

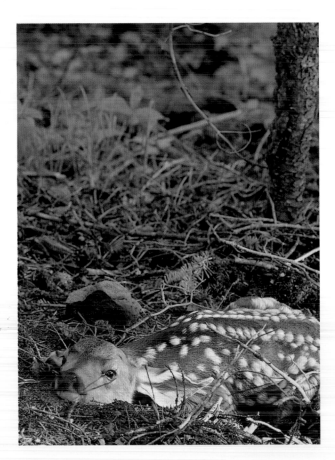

Right: Being born without a scent and keeping perfectly still and low to the ground help to make newborns such as this mule deer less vulnerable to predators.

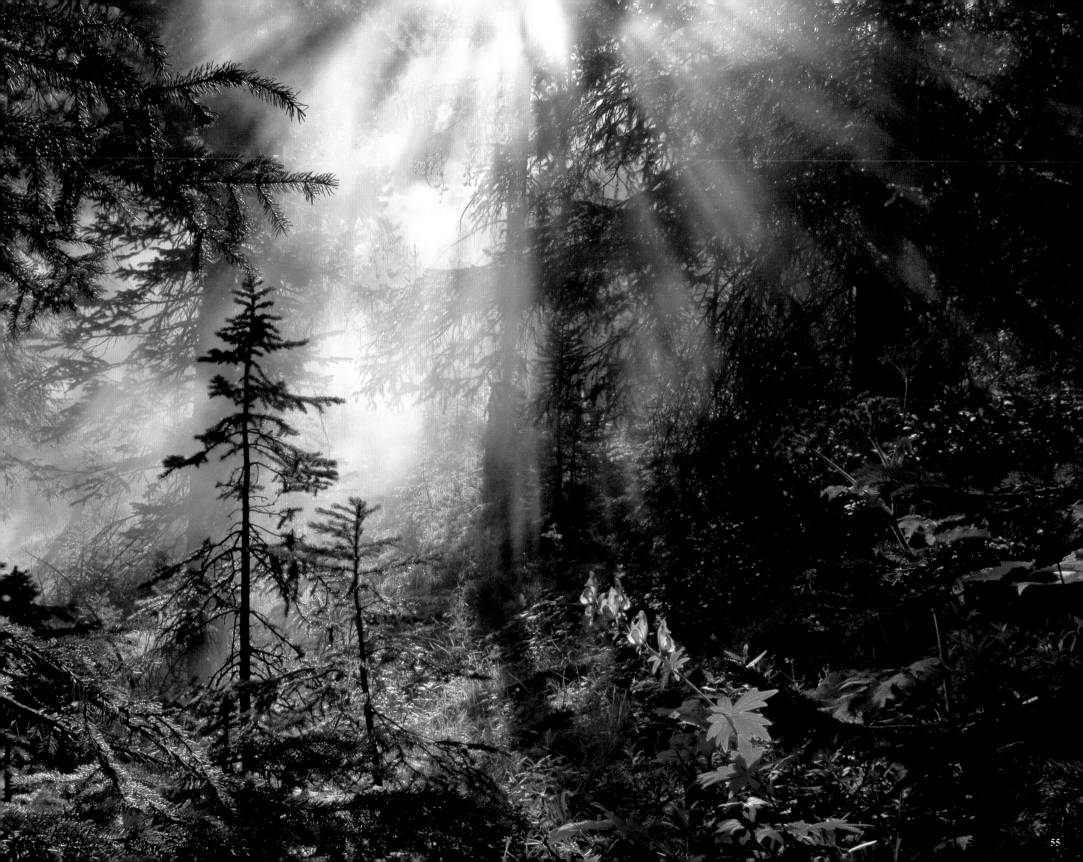

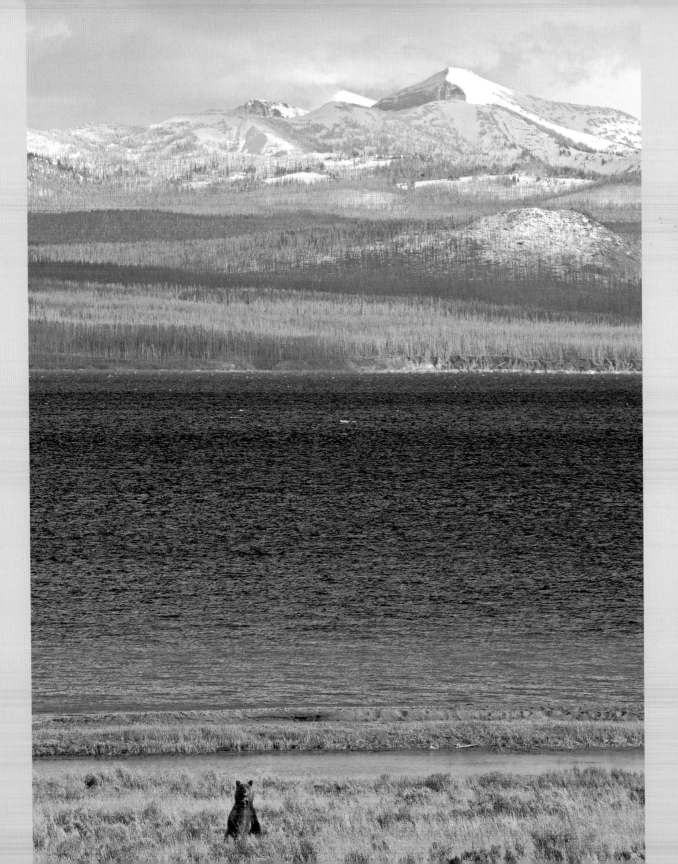

Left: A curious sow grizzly rears up from her almost constant foraging. Yellowstone Lake is in the background.

Facing page: Yoga Bear. This young grizzly appears to be doing his morning calisthenics. He's really just playing with dragonflies that are flying over his head.

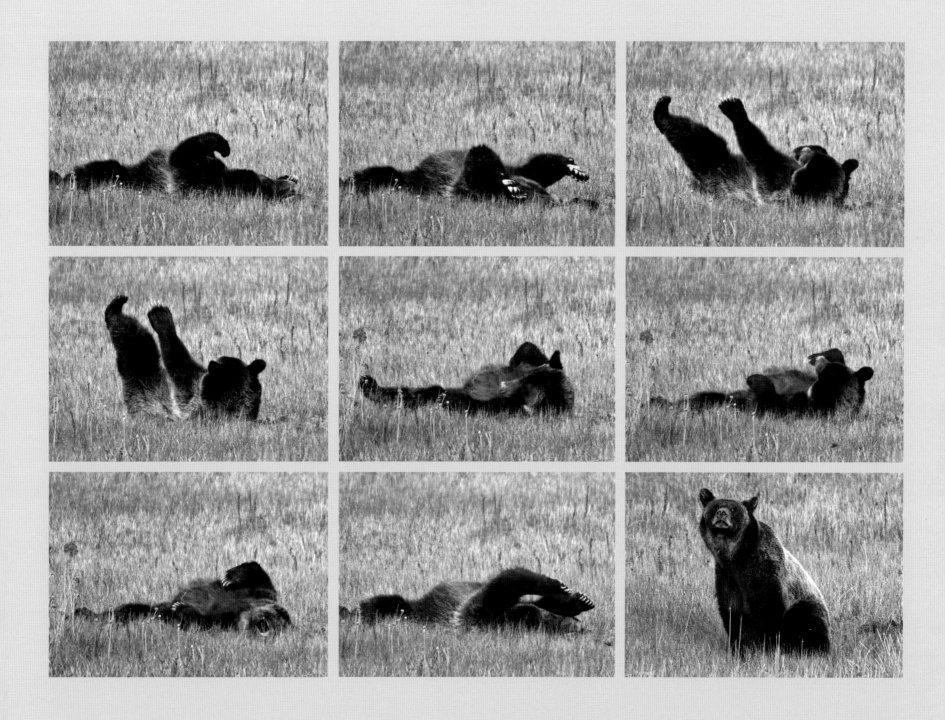

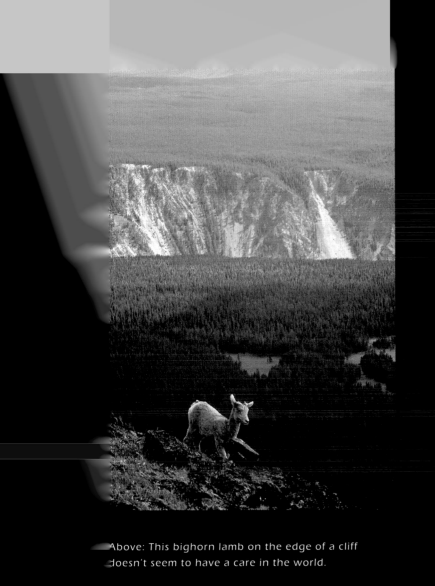

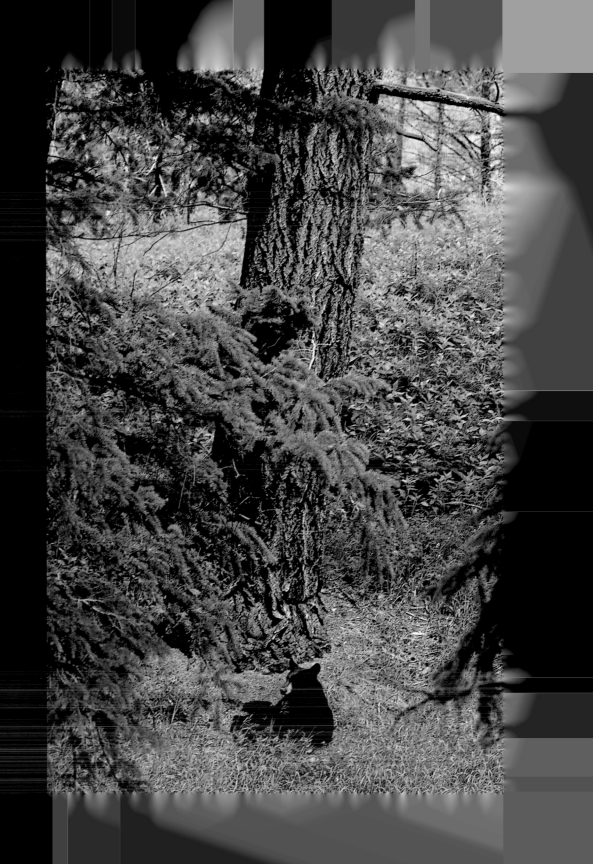

Above: This bighorn lamb on the edge of a cliff doesn't seem to have a care in the world.

Right: A young black bear awakens from a nap just in time to get his picture taken.

Facing page: Washburn Hot Springs and a fog-filled Yellowstone Canyon at the base of Mt. Washburn.

Following pages: An aerial view of Crater Hills in Hayden Valley and a grizzly bear fording the Yellowstone River near the Mud Volcano area.

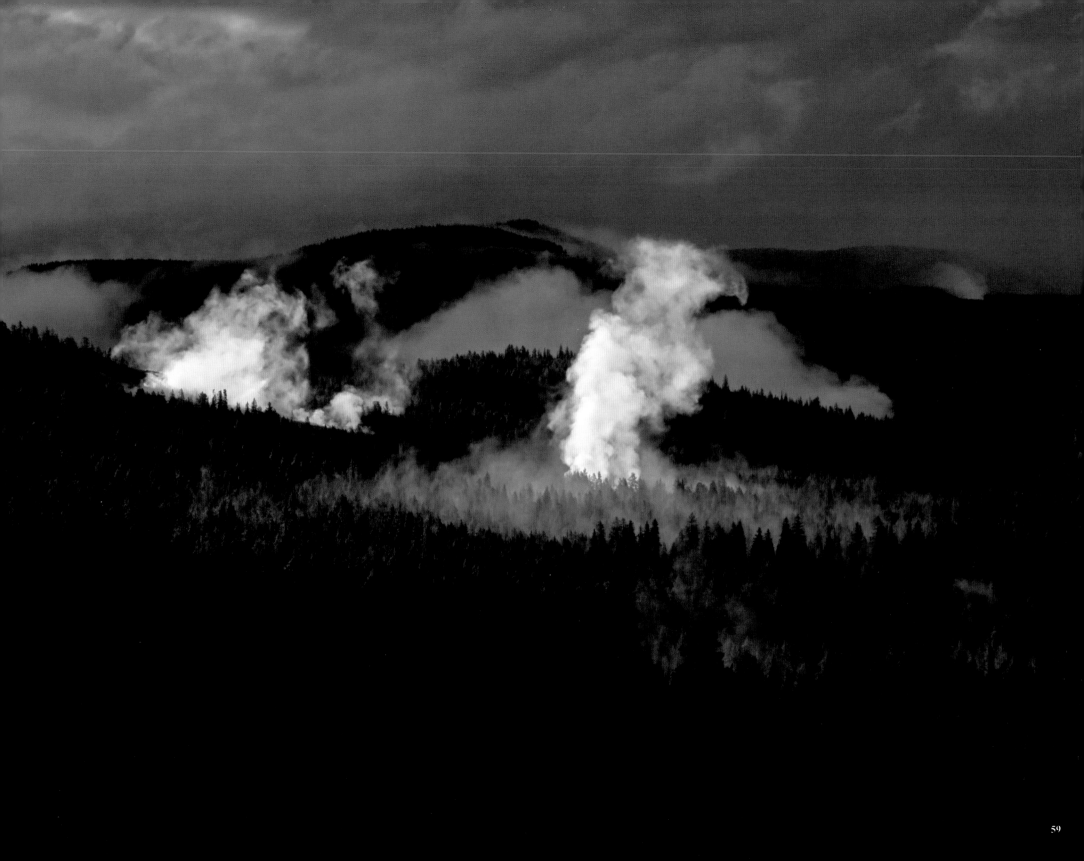

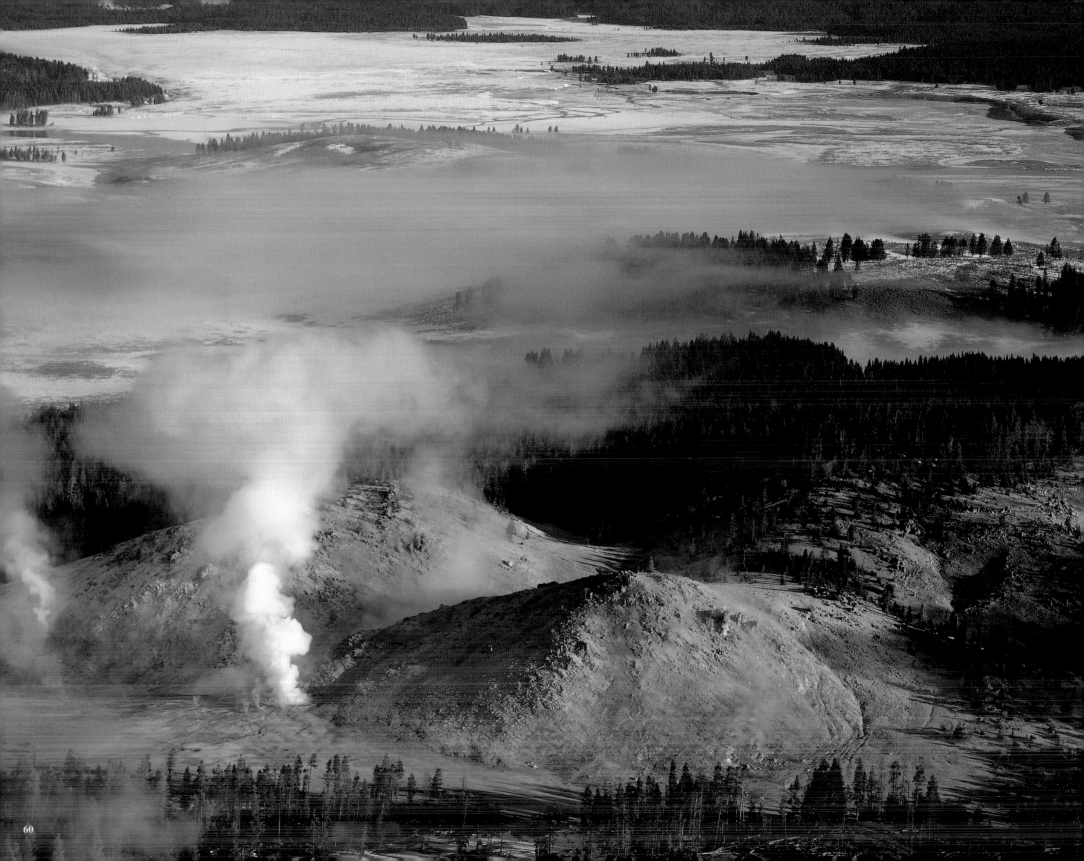

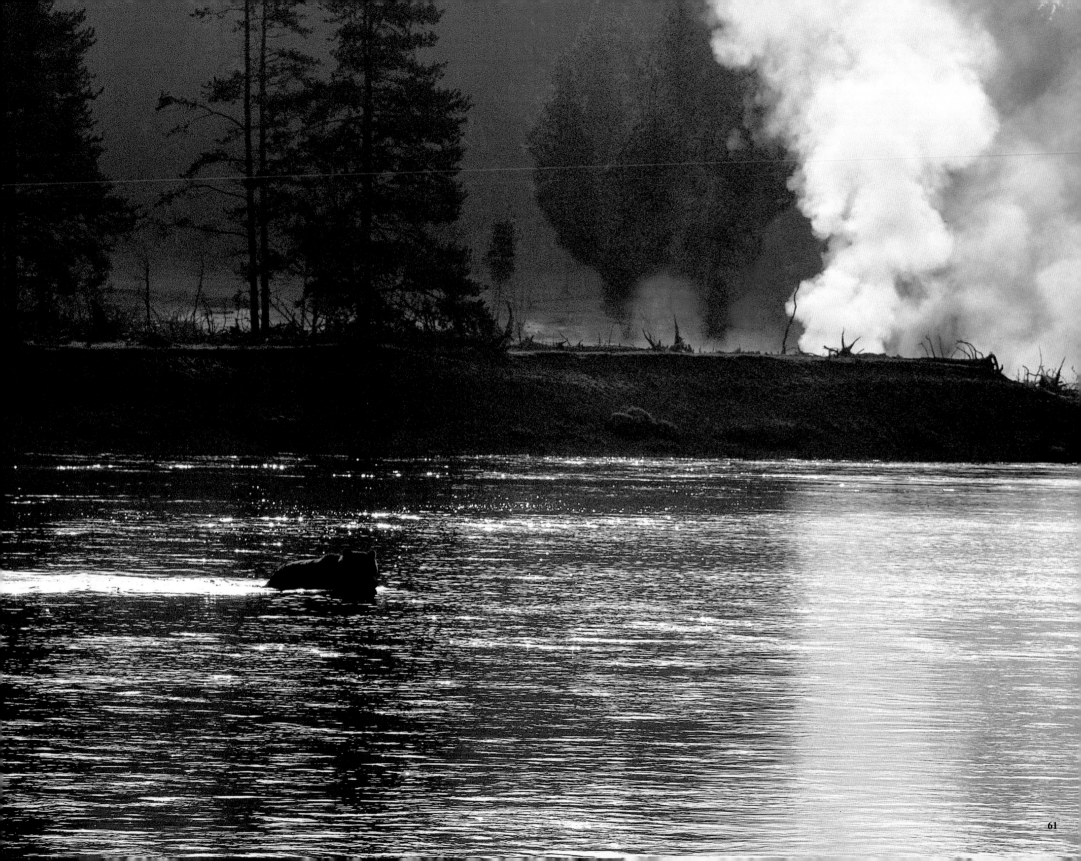

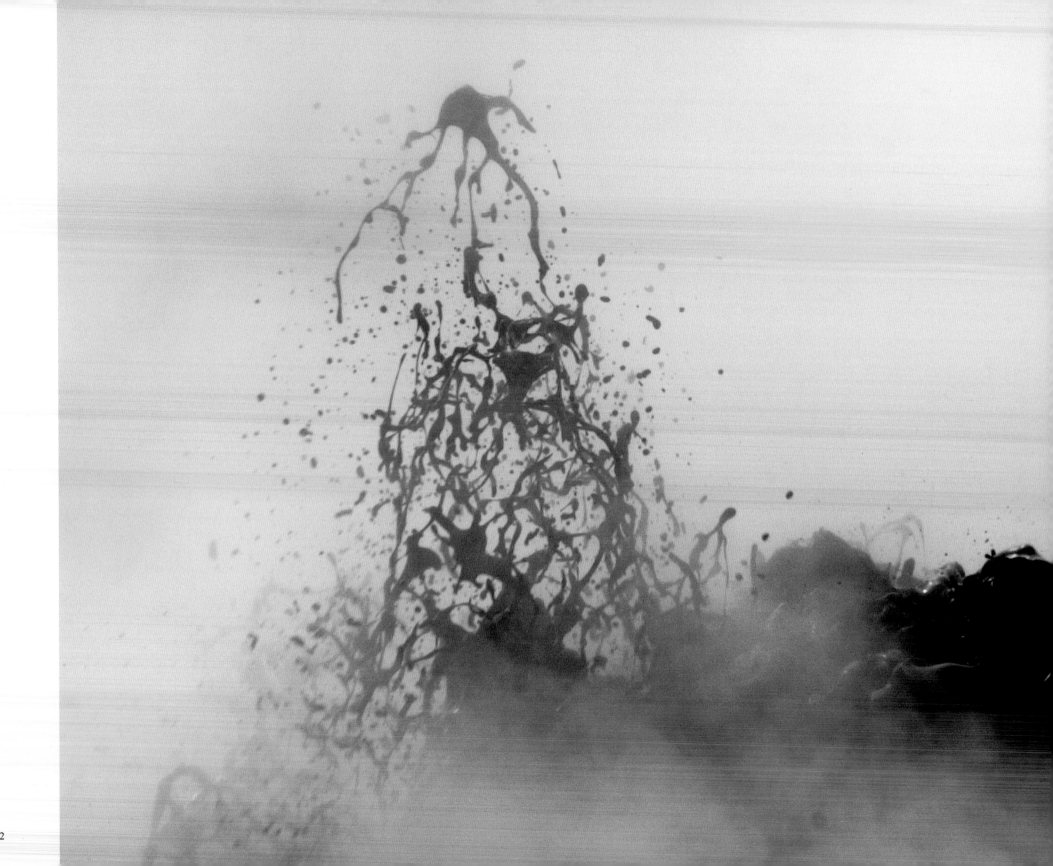

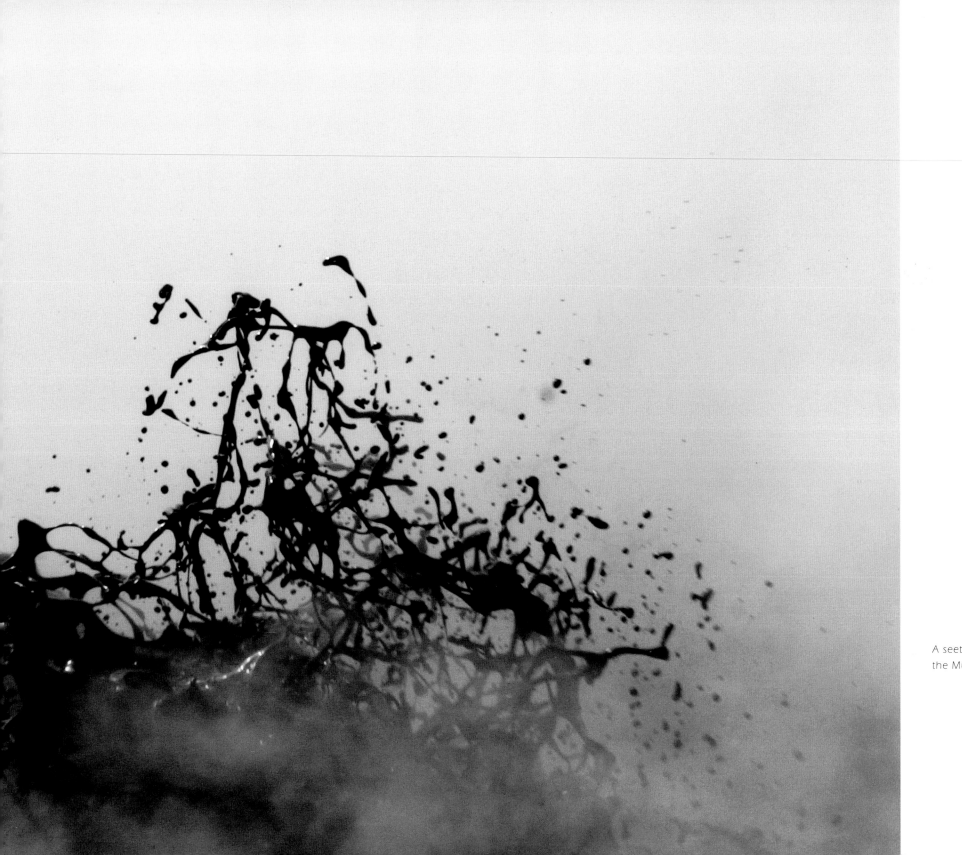

A seething cauldron in
the Mud Volcano area.

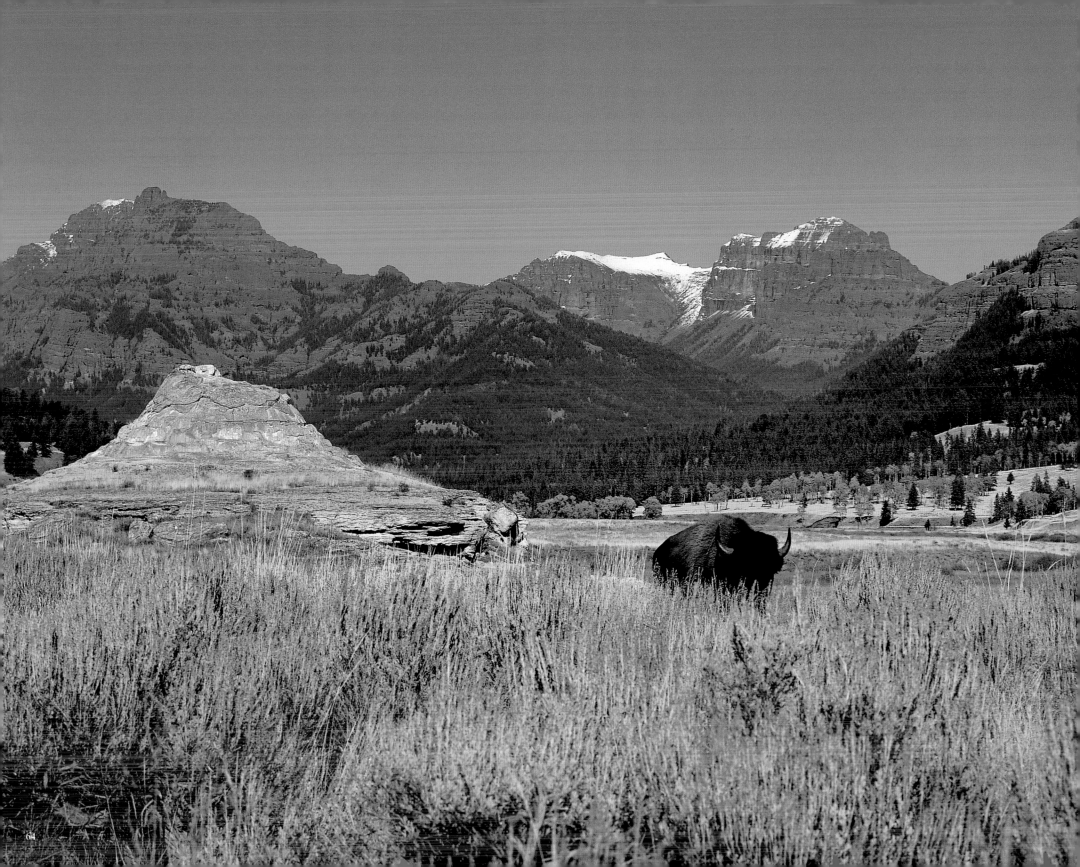

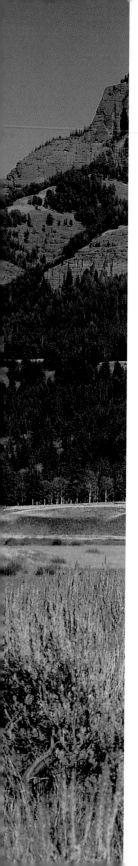

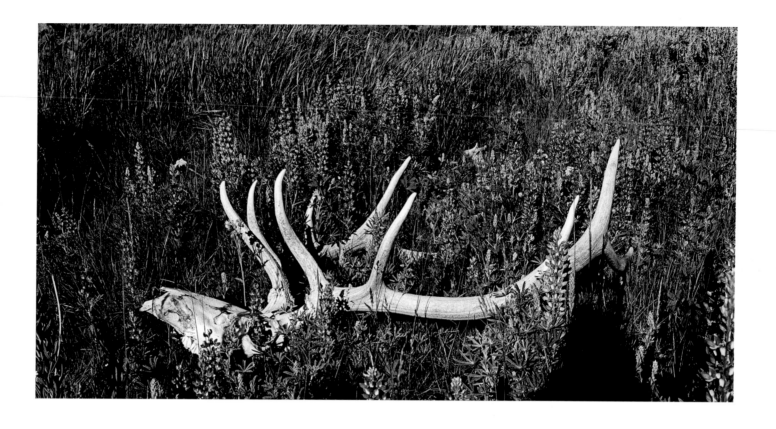

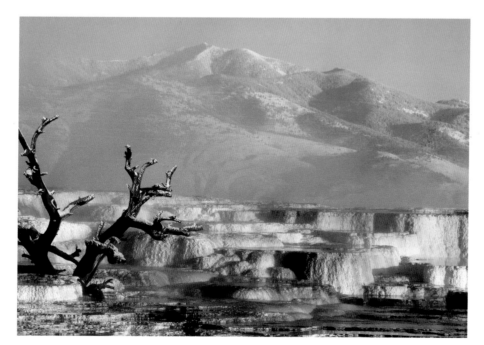

Above: Lupines grow on a hillside and around an elk skull in the Lamar Valley.

Left: Travertine terraces at Mammoth Hot Springs.

Far left: Soda Butte in the northeast corner of Yellowstone was once an active hot spring if not an actual geyser. Bison are often seen grazing nearby.

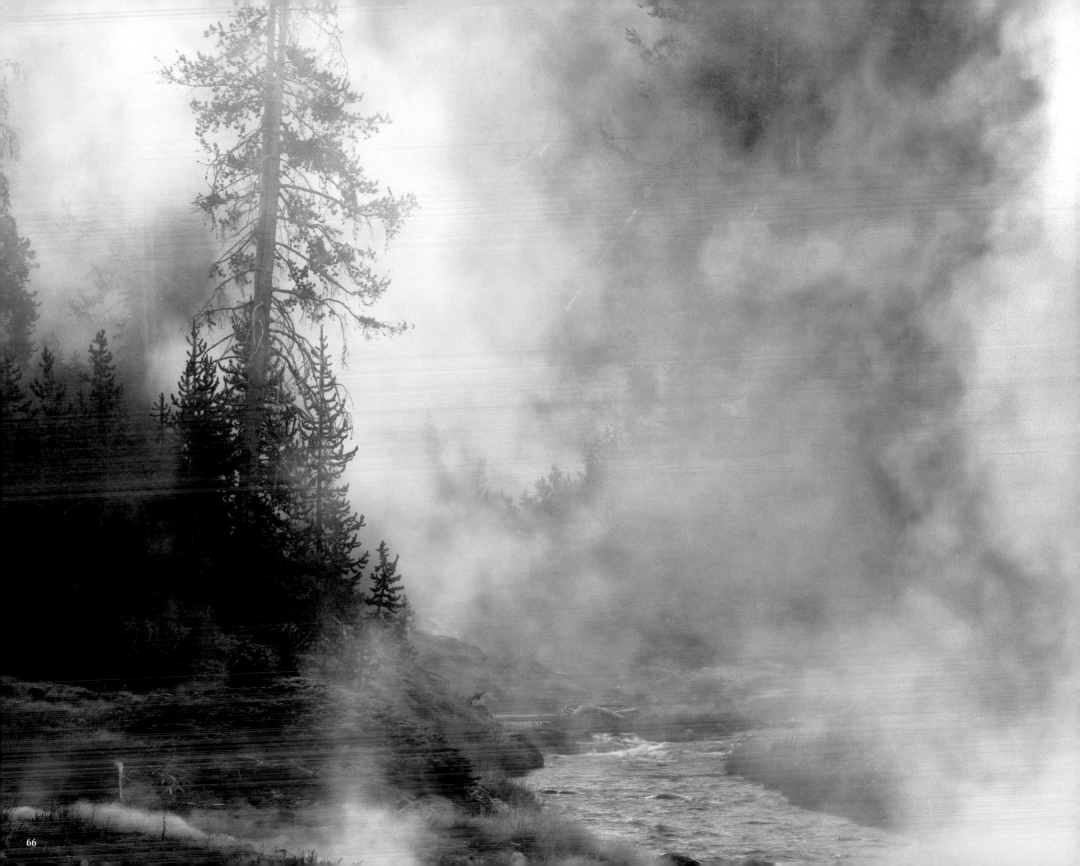

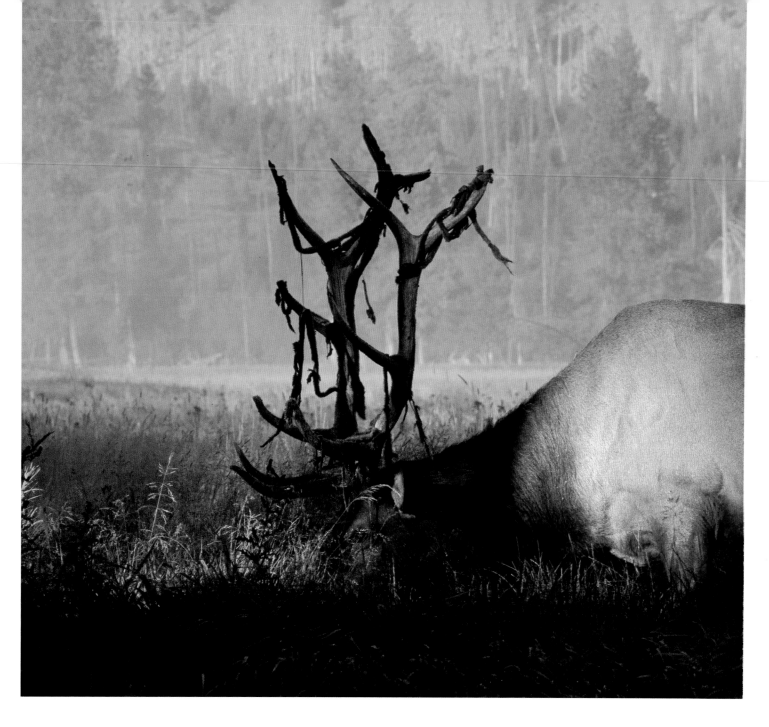

Above: A six point bull elk more or less in velvet.

Left: The Ferris Fork of the Bechler River on a
cold September morning.

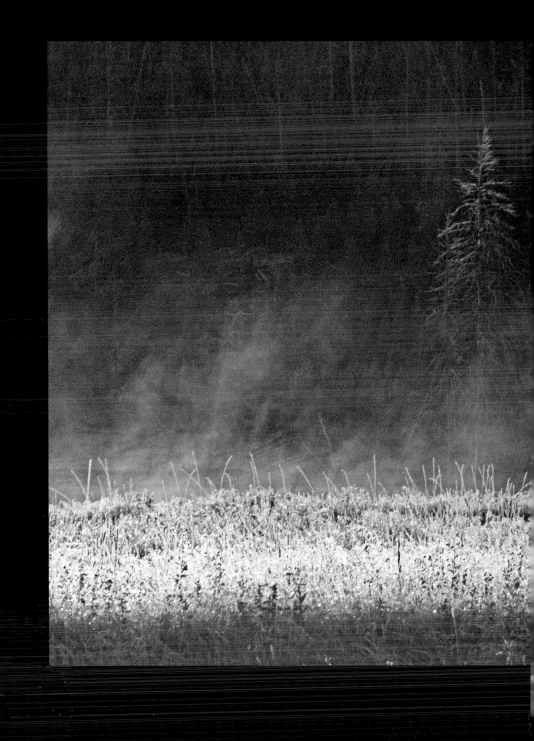

Above: A typical tree used by bull elk
for shedding velvet from their antlers.

Right: A typical post-velvet elk.

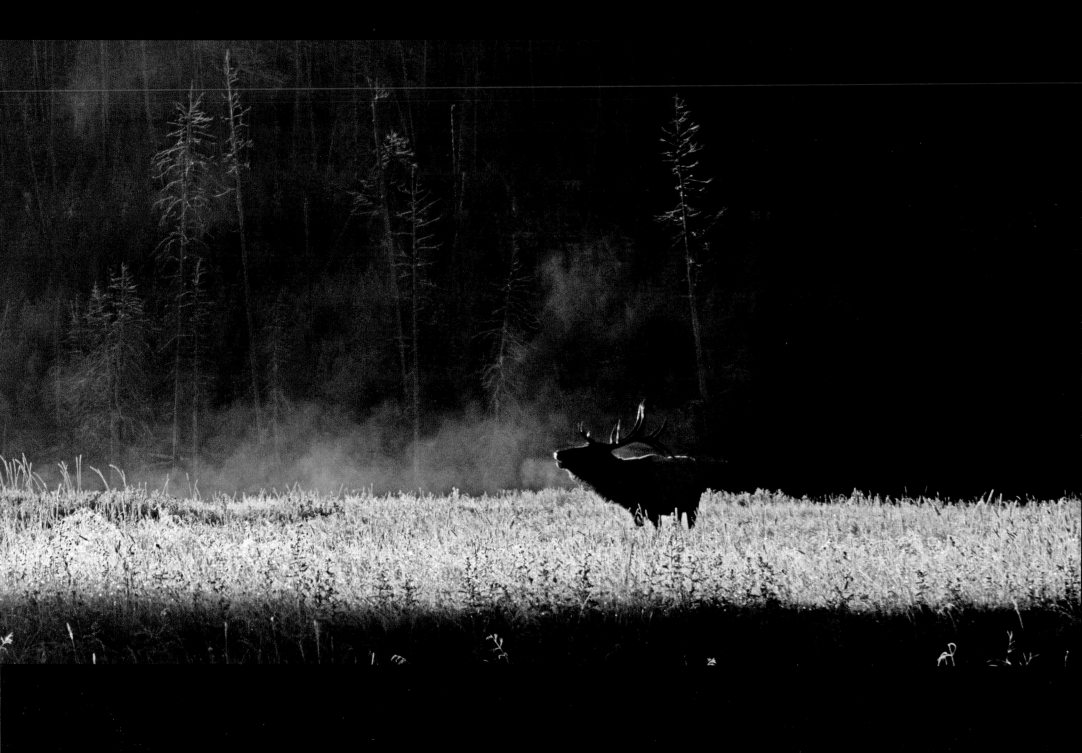

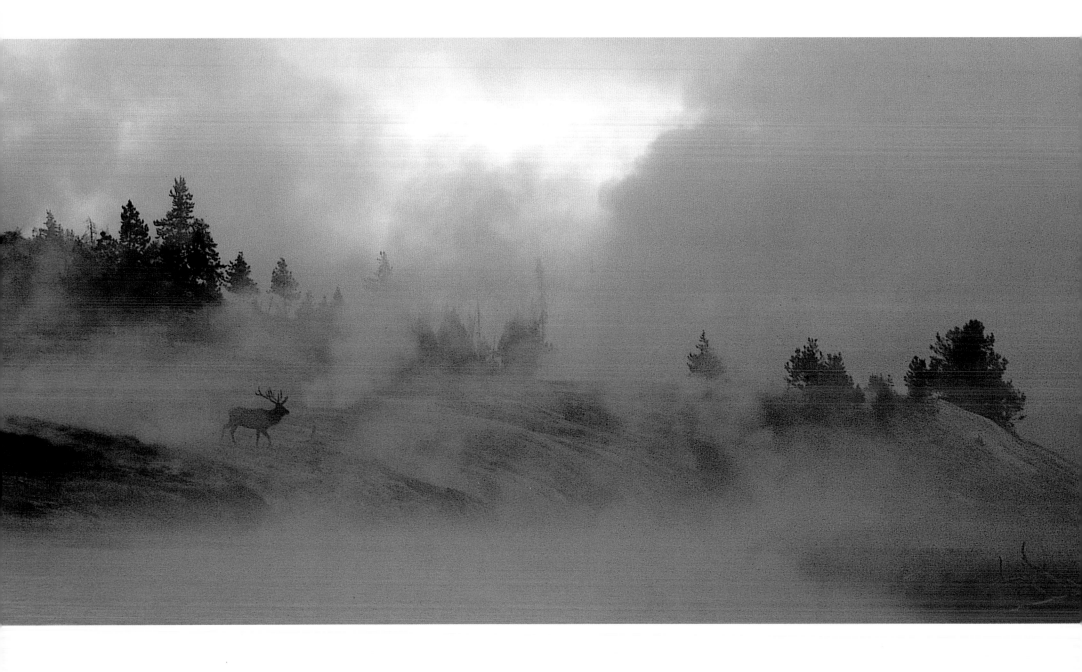

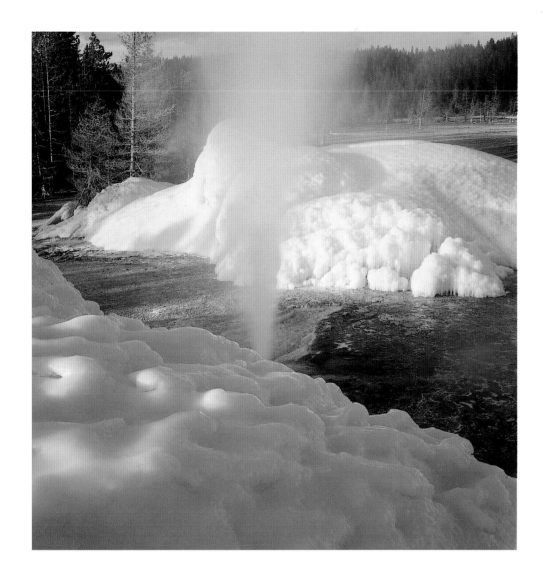

Above and right: Steam and mist decorate
the surrounding area with "geyser frosting."

Facing page: A stately bull elk strikes a pose
along the banks of the Firehole.

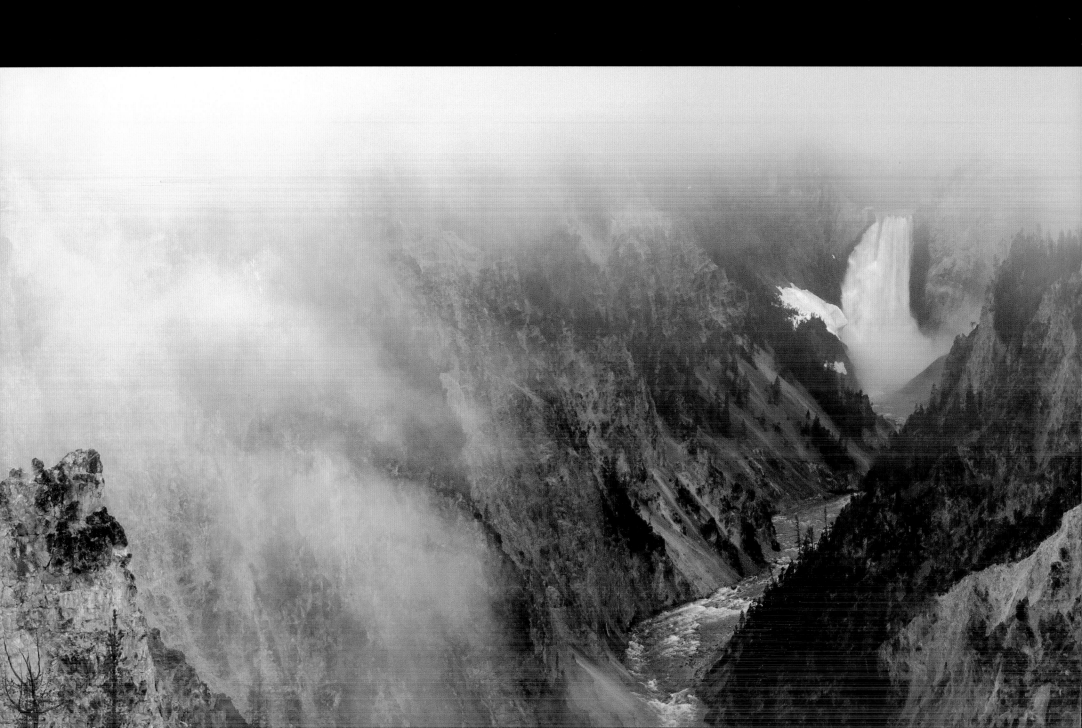

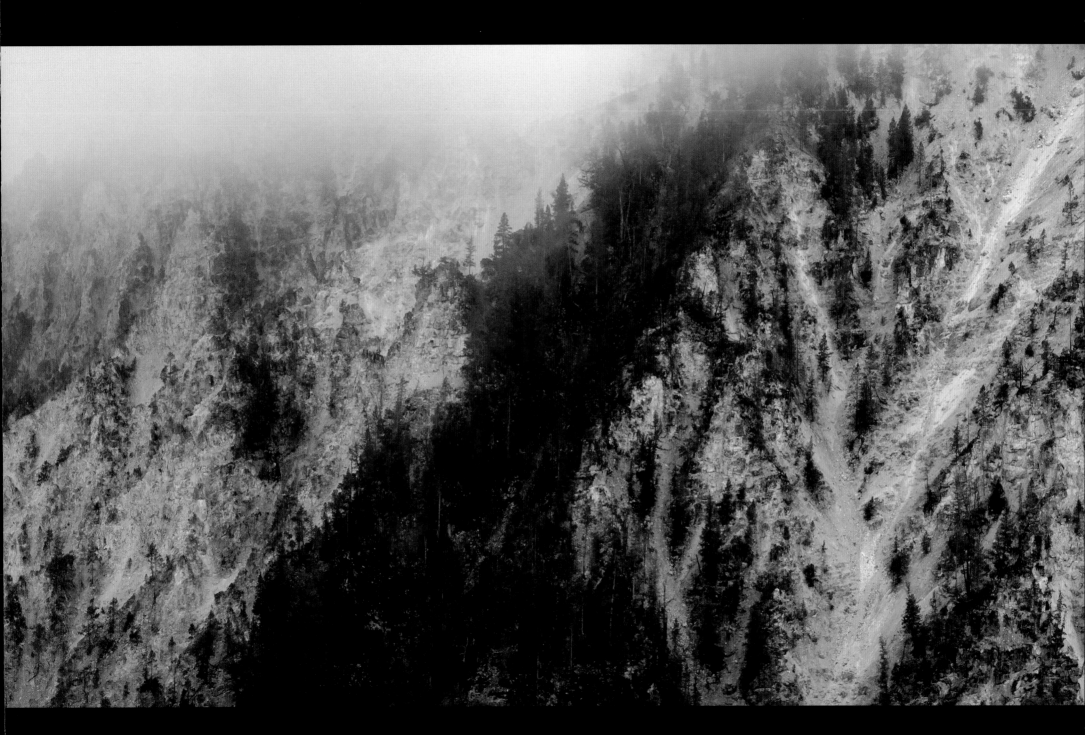

The Grand Canyon of the Yellowstone River.

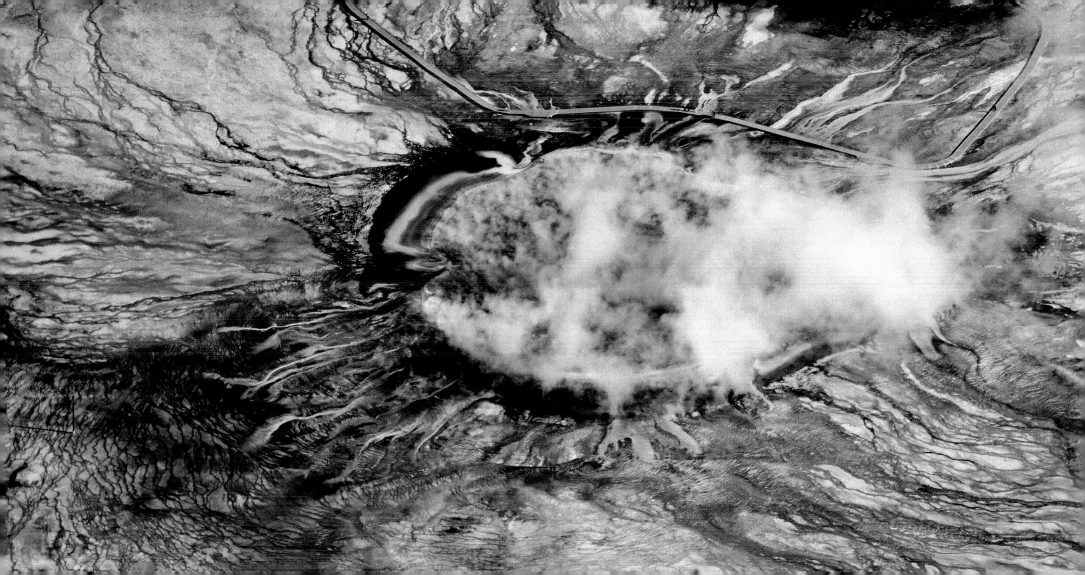

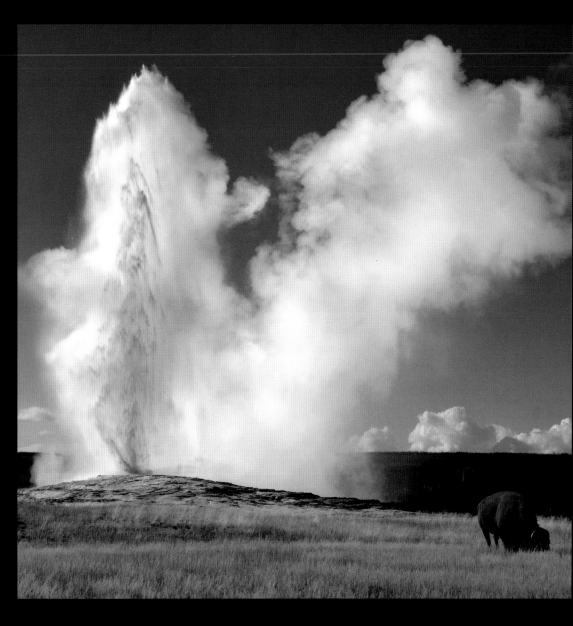

Old Faithful and bison.

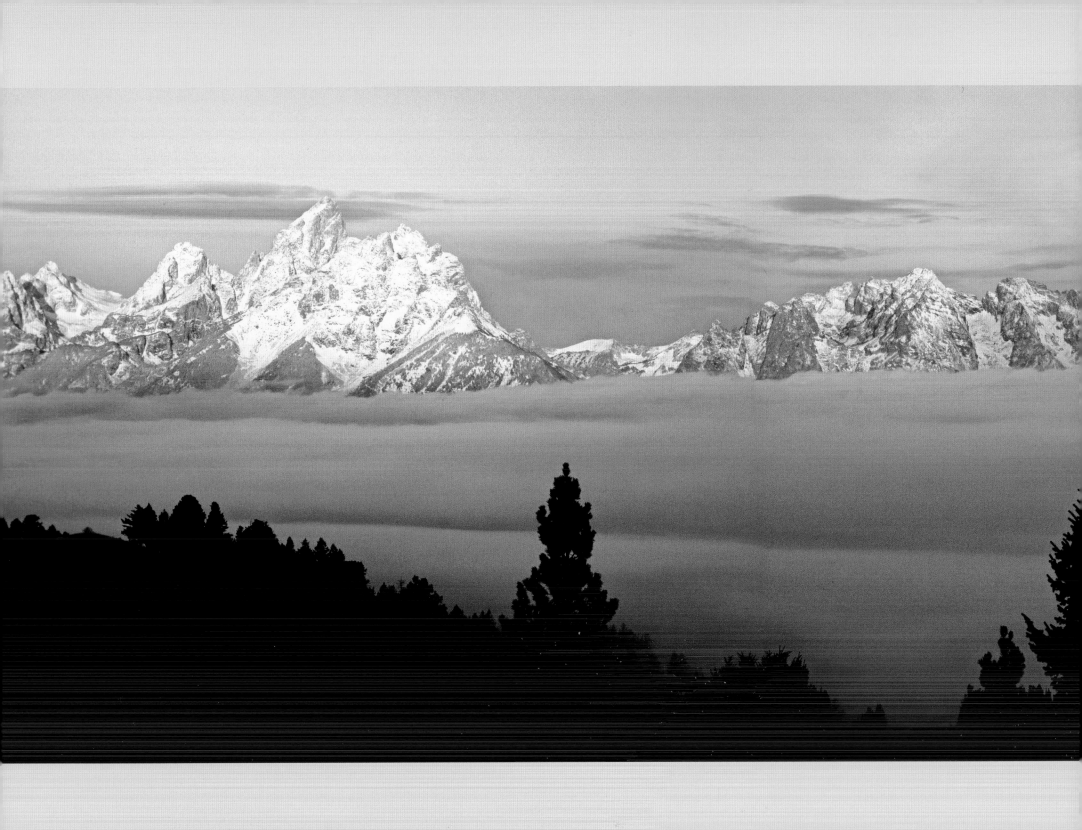

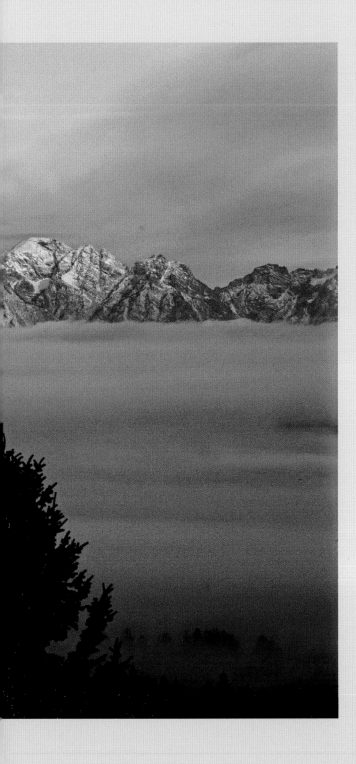

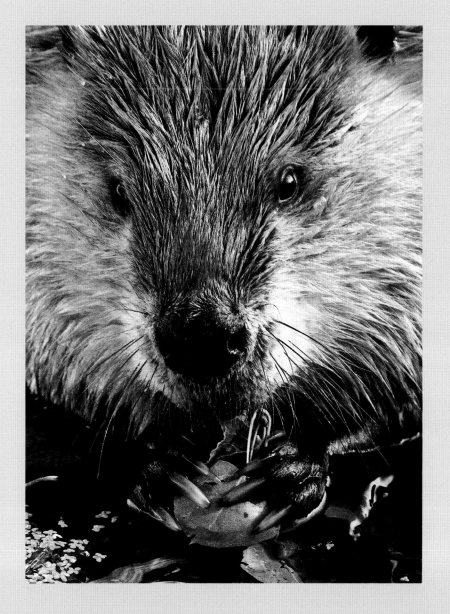

Above: North American beaver.

Left: Jackson Hole is named for trapper Davy Jackson.
The fur trade played an important role in opening up
the Rocky Mountain West for exploration. And what
was trapped was primarily beaver.

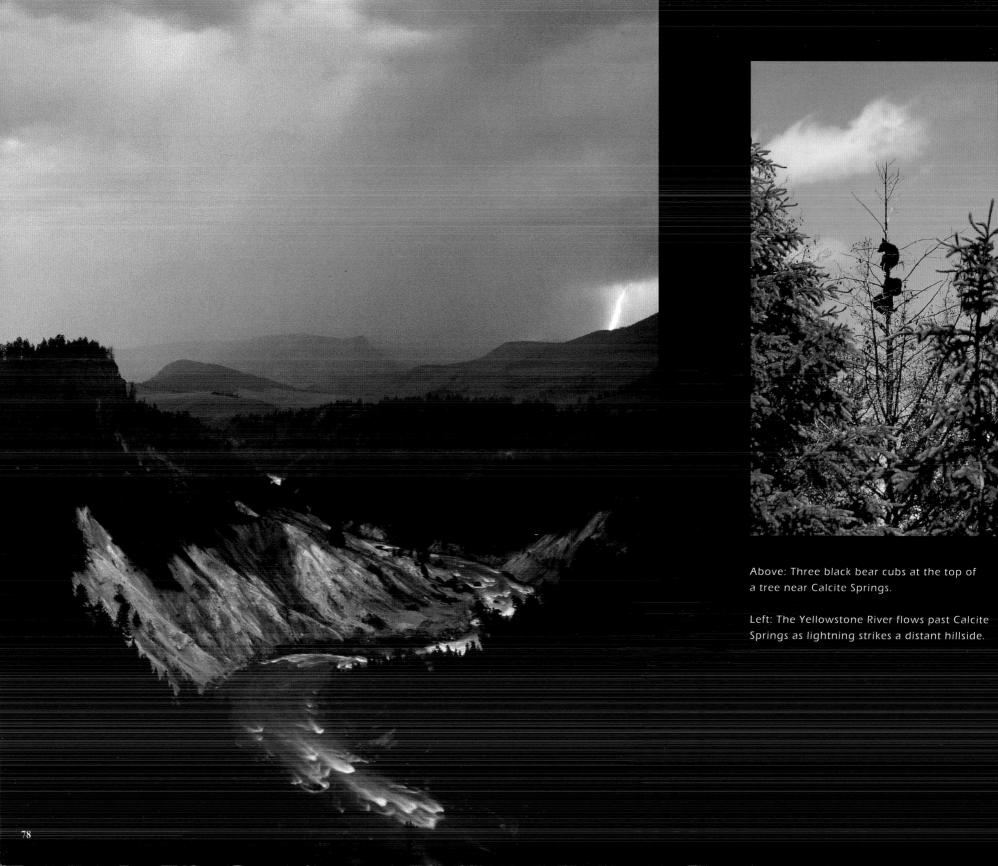

Above: Three black bear cubs at the top of a tree near Calcite Springs.

Left: The Yellowstone River flows past Calcite Springs as lightning strikes a distant hillside.

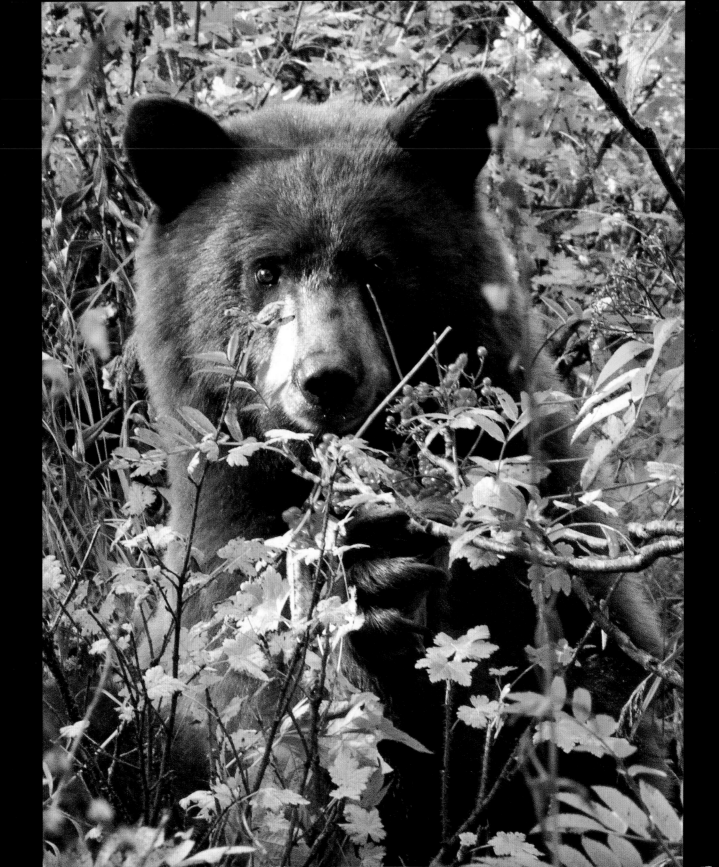

A cinnamon-colored black bear uses his claws to rake in mountain ash berries.

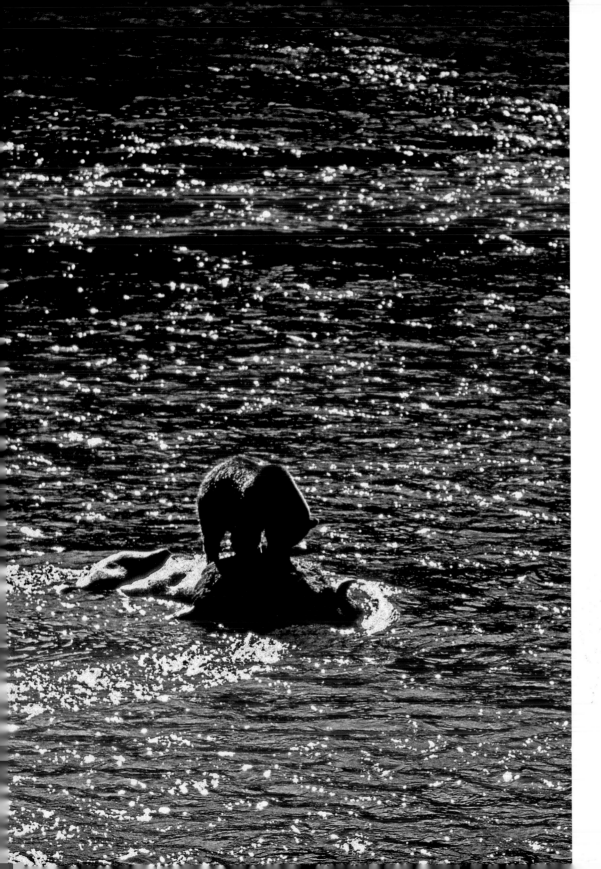

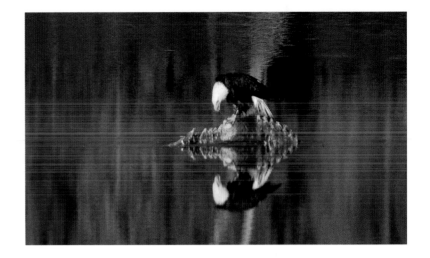

This page: Often animals will try to escape predators by crossing a river or some other body of water—but they don't always make it. The above elk was taken down by wolves in a shallow part of Nymph Lake. After the wolves had their fill, the rest was left for eagles and ravens. The same basic scenario probably occurred for the respective bison left and below.

Facing page: Sandhill cranes at Madison Junction.

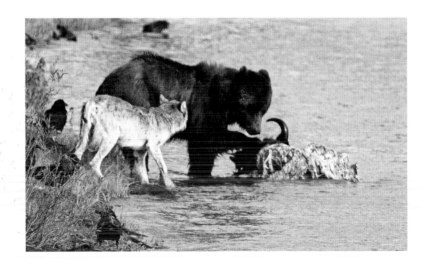

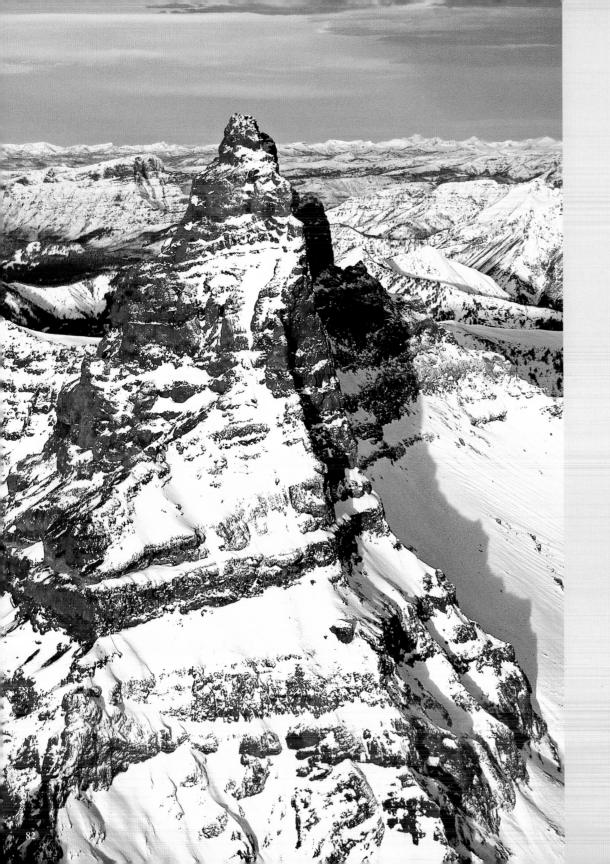

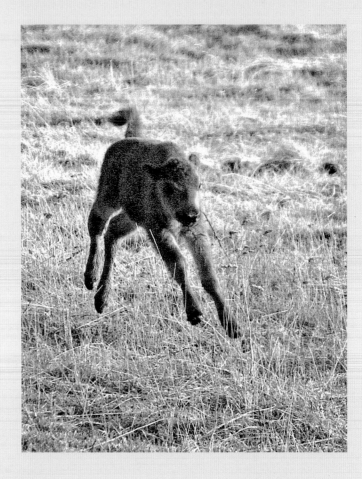

The Absarokas, among other mountain ranges, were a formidable barrier to early exploration and subsequent human habitation of the Yellowstone area. One notable exception, the Sheepeater Indians, found refuge from other, more warlike tribes in this seemingly impenetrable wilderness. And of course it has always been a playground for wildlife.

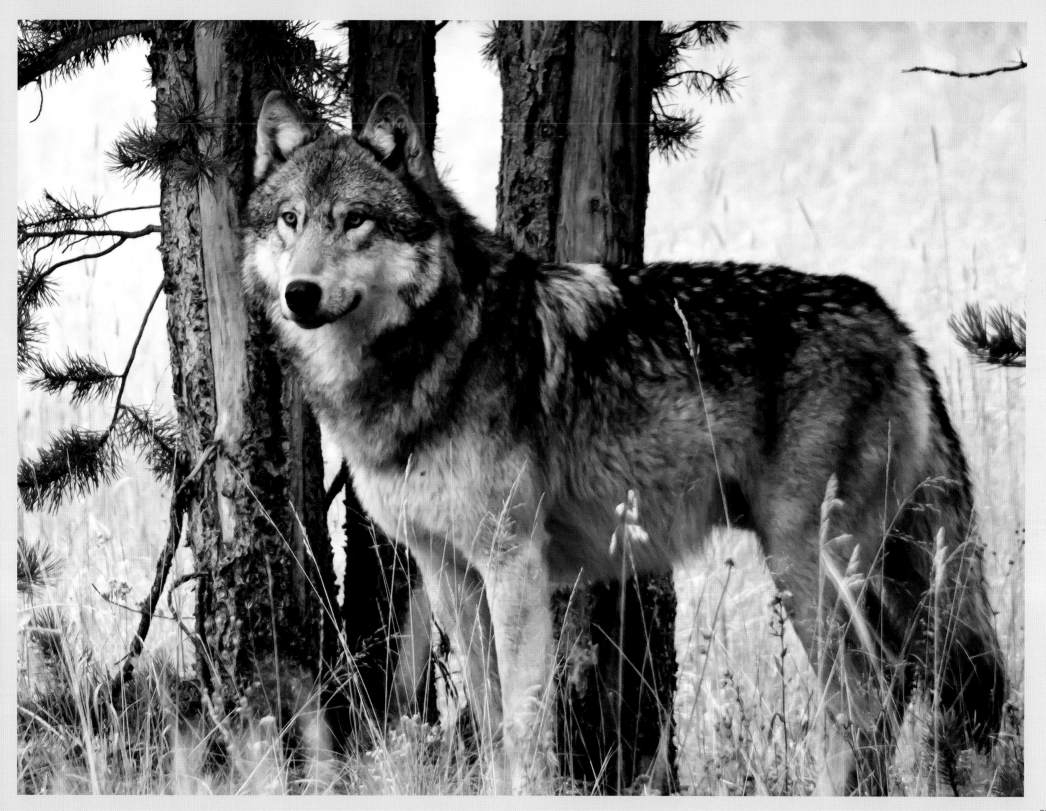

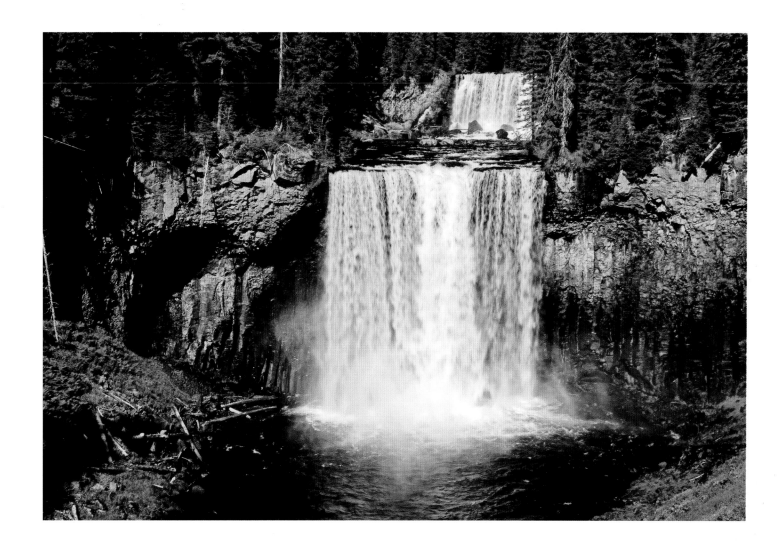

When passing through the vast Thoroughfare region of southeast Yellowstone—
or over it (left)—it's not hard to imagine Jim Bridger wading the icy streams and
setting his beaver traps. This area was one of the iconic mountain man's favorite haunts.

The Bechler and Falls River drainage, also known as Cascade Corner, attracts hikers
from all over the world. Colonnade Falls, above, is just one of the many backcountry
waterfalls you can visit there.

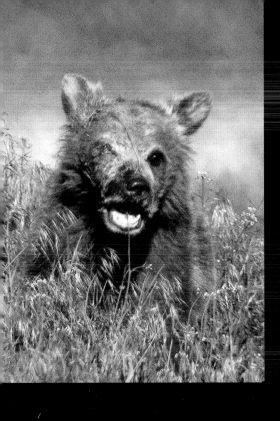

This little guy, a grizzly cub, appears
to have had a rough start to his life.
He was seen roaming the upper
Firehole River drainage, not far from
Black Sand Geyser Basin (right).

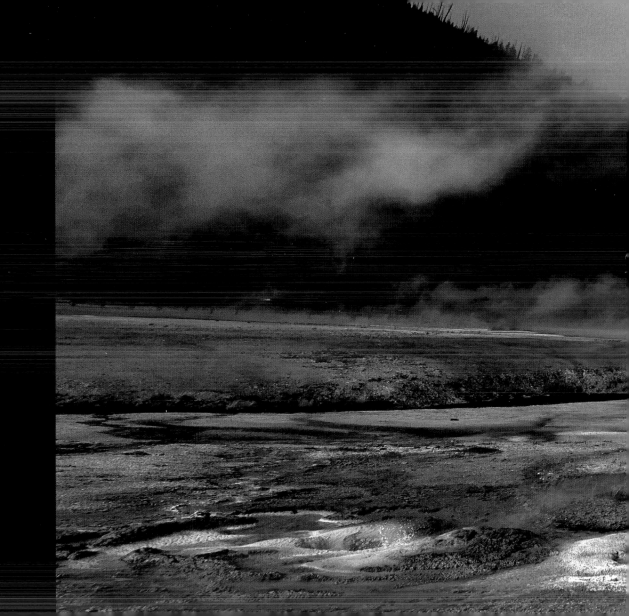

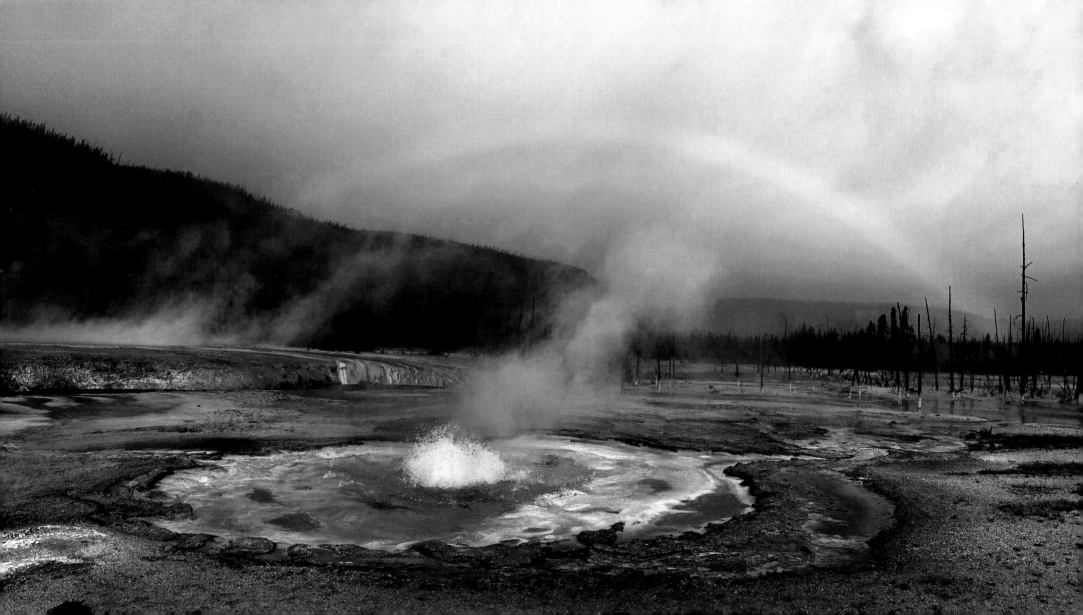

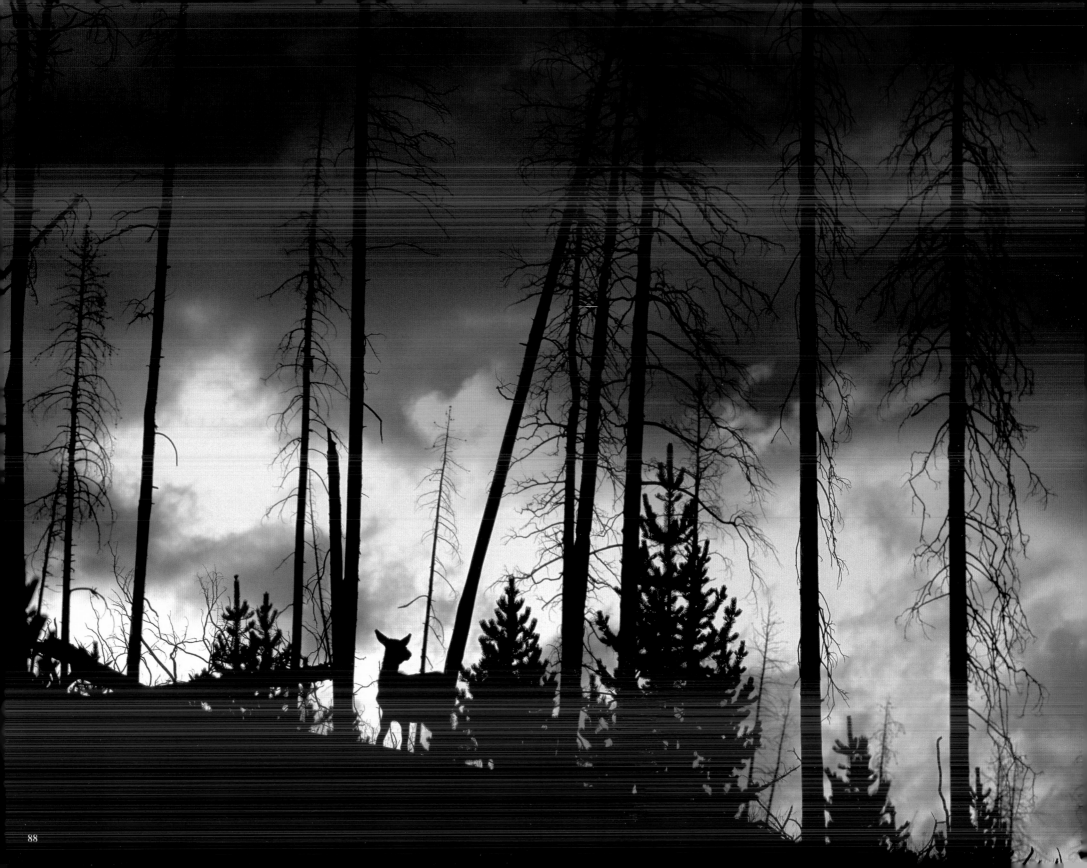

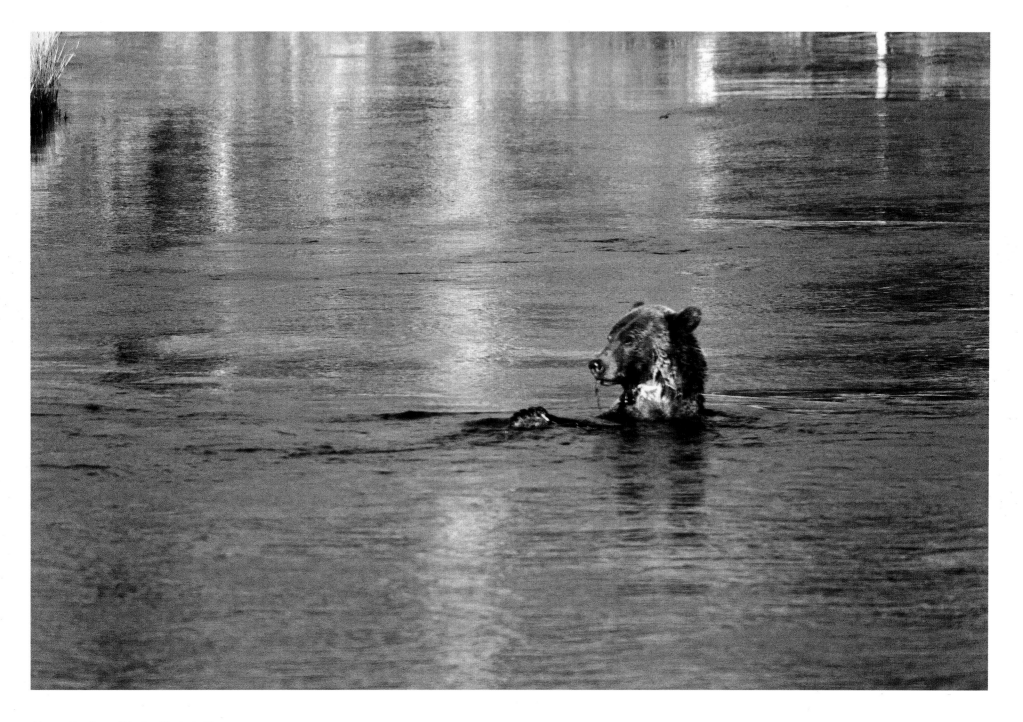

Above: Cooling off in the Firehole River.

Facing page: A cow elk pauses from her grazing to have a look around.

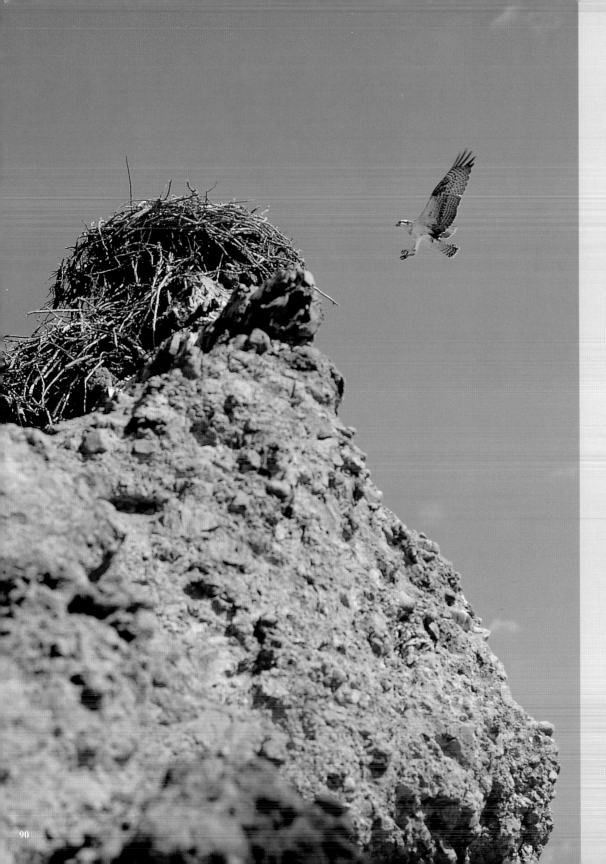

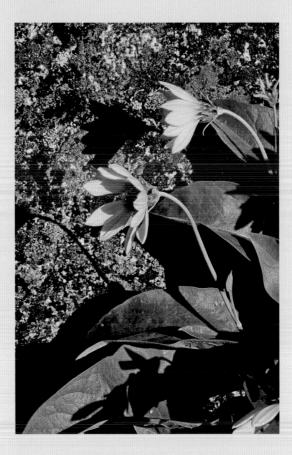

Above: Arrowleaf balsamroot can be found on open hillsides and meadows throughout both parks.

Left: An osprey tends to her nest in The Narrows near Tower Falls.

Right: Tower Creek winds through volcanic rock pinnacles and gog before plummeting 132 feet amid mixed conifers.

Below: Seeing eye-to-eye. Small birds tend to follow bison in order to eat the insects that are stirred up by the animals' hooves. A classic symbiotic relationship, they're also often seen perched on the backs of these and other large ungulates, feasting on similar pests.

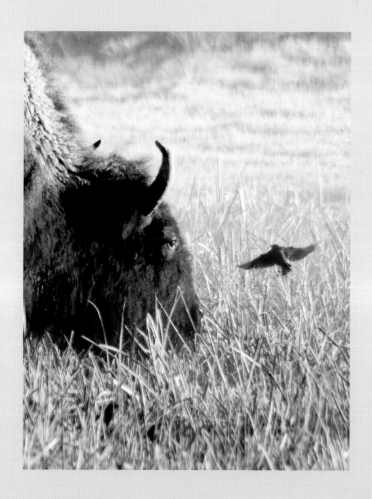

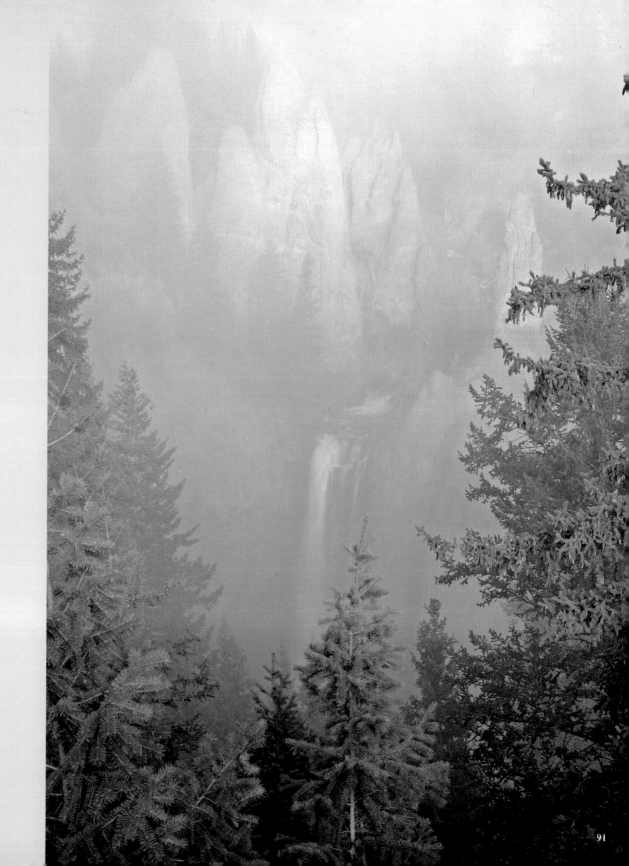

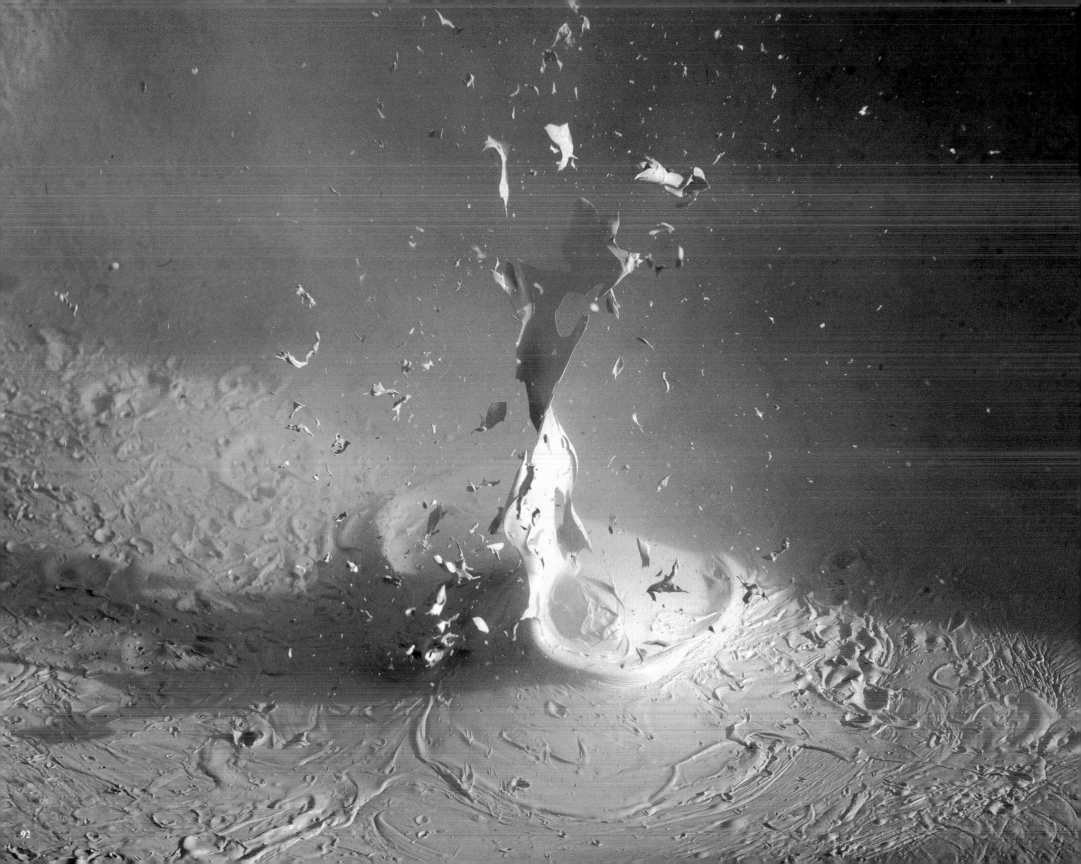

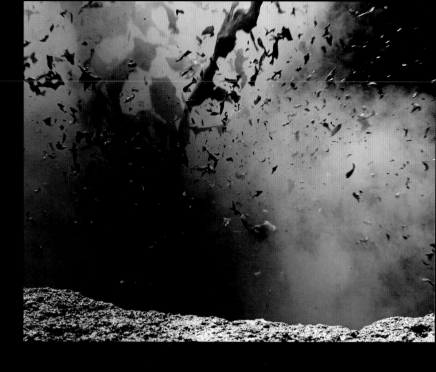

Yellowstone mud has many moods, most of them pretty foul. The park features every type of mud pot imaginable. Some will bubble, some will churn or spatter, and still others will erupt—violently—and unpredictably.

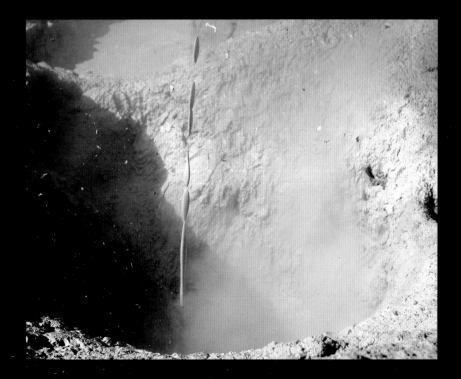

If you're lucky and the conditions are just right, you might even witness a rare "rope eruption" (left). But leaving the boardwalks in thermal areas is unlawful, not to mention dangerous. So a telephoto lens comes in handy, and can even create the effect of your being right in the middle of a virtual mud storm (above).

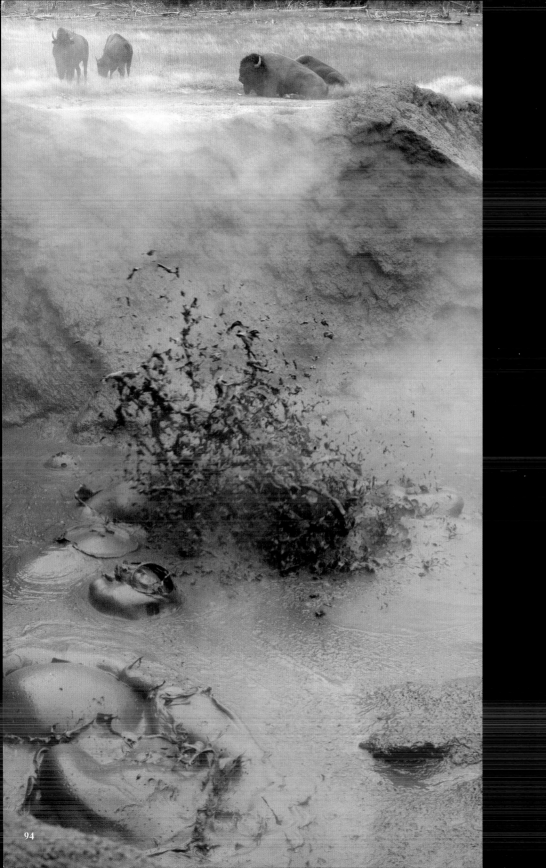

Bison are drawn to thermal areas, especially ones with mud. They like to wallow in the acidic soil associated with such features. And not all mud pots are seething cauldrons (left), or at least they don't start out that way. The "mini-mud pot" above, as measured by the bison hoofprint next to it, may someday grow into something much more impressive.

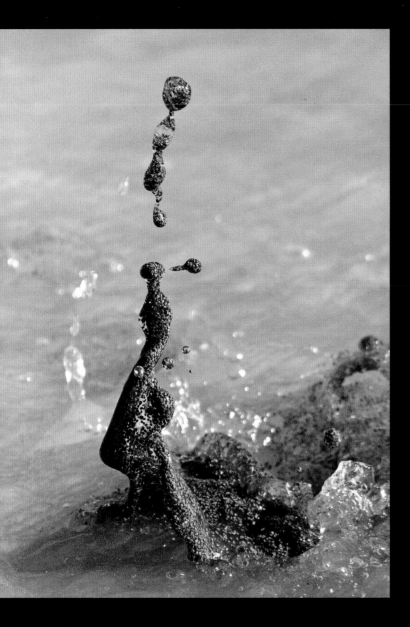

Above: Erupting mud spring at Turbid Lake.

Right: These prints show that a bear walked
right through a bubbling mud feature.

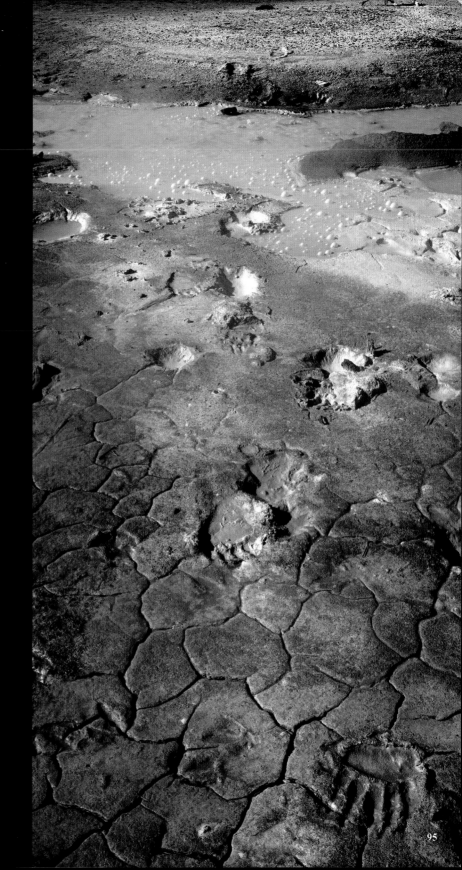

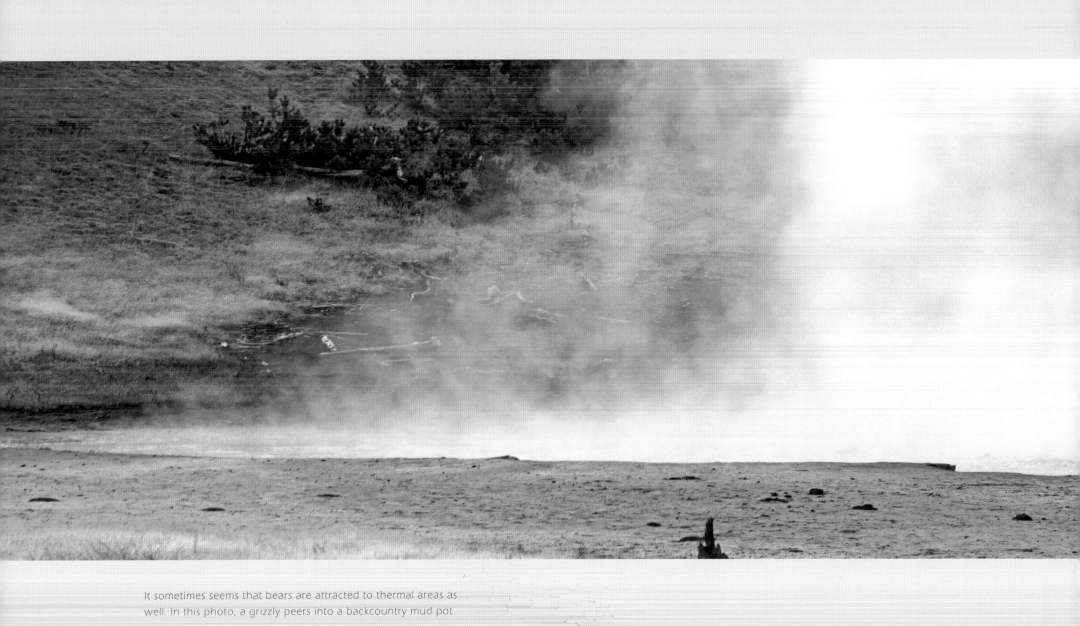

It sometimes seems that bears are attracted to thermal areas as well. In this photo, a grizzly peers into a backcountry mud pot.

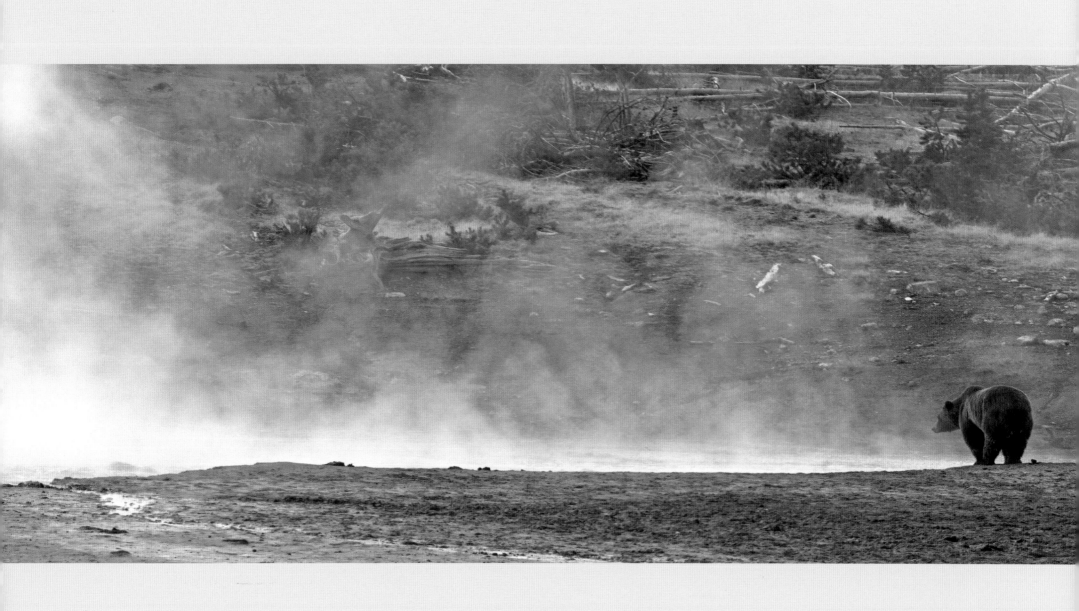

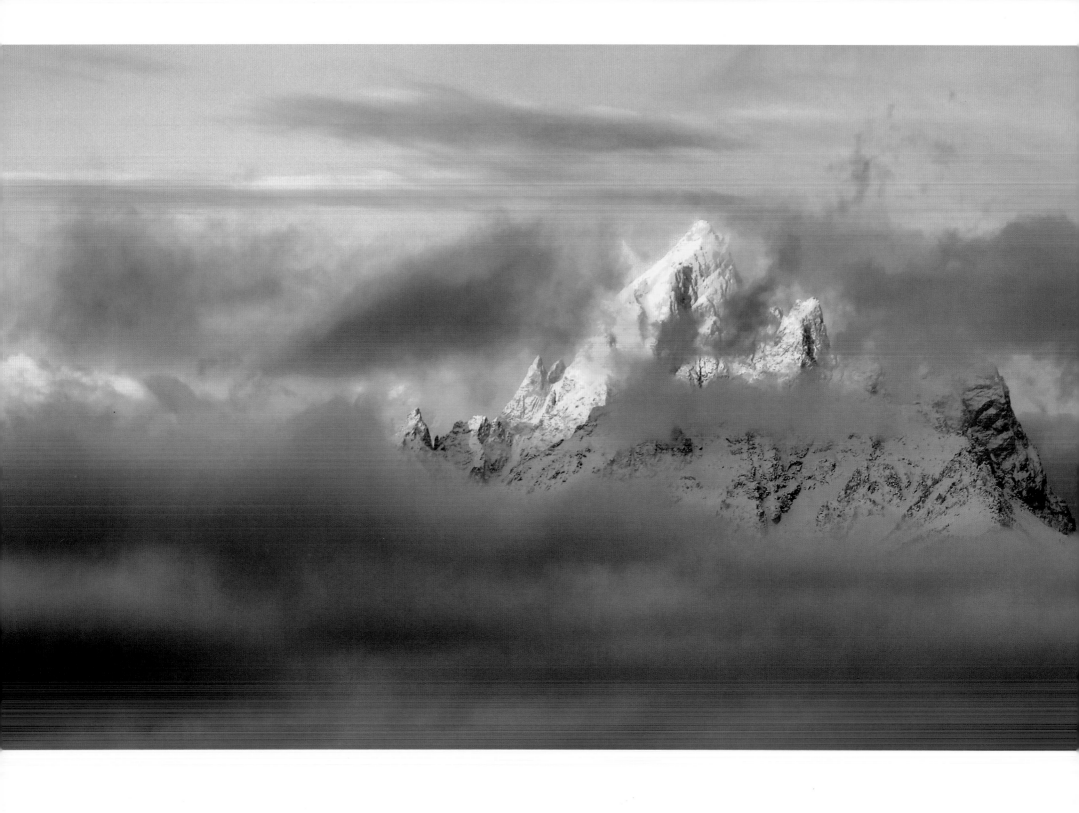

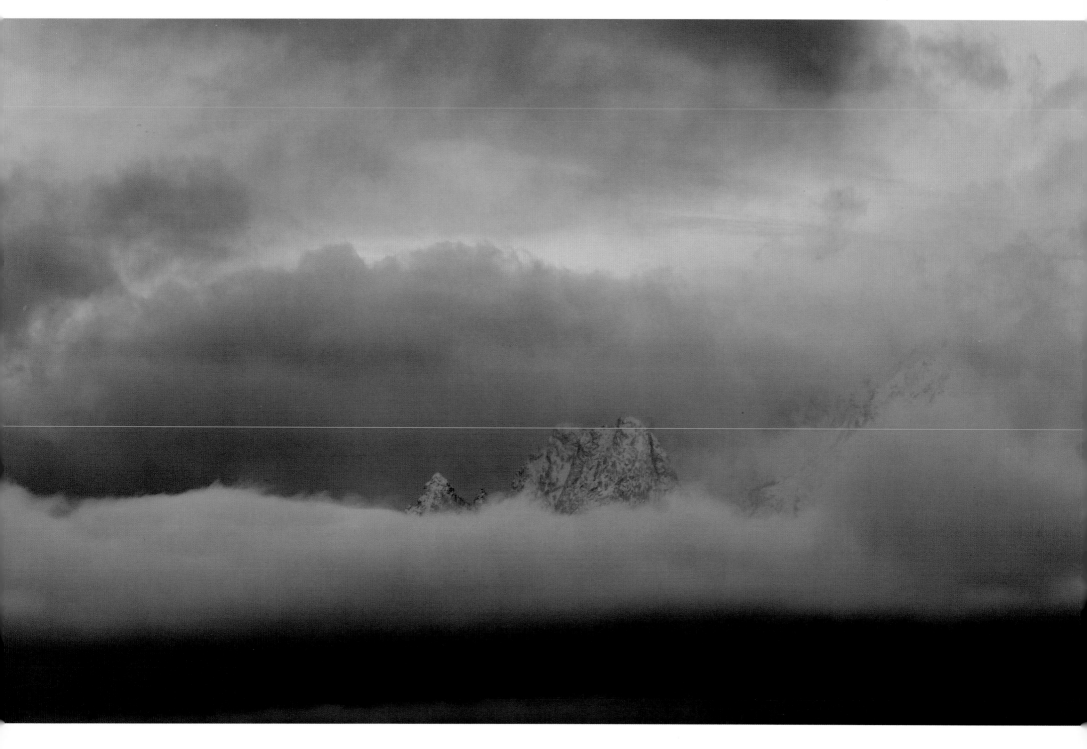

First light in Grand Teton National Park.

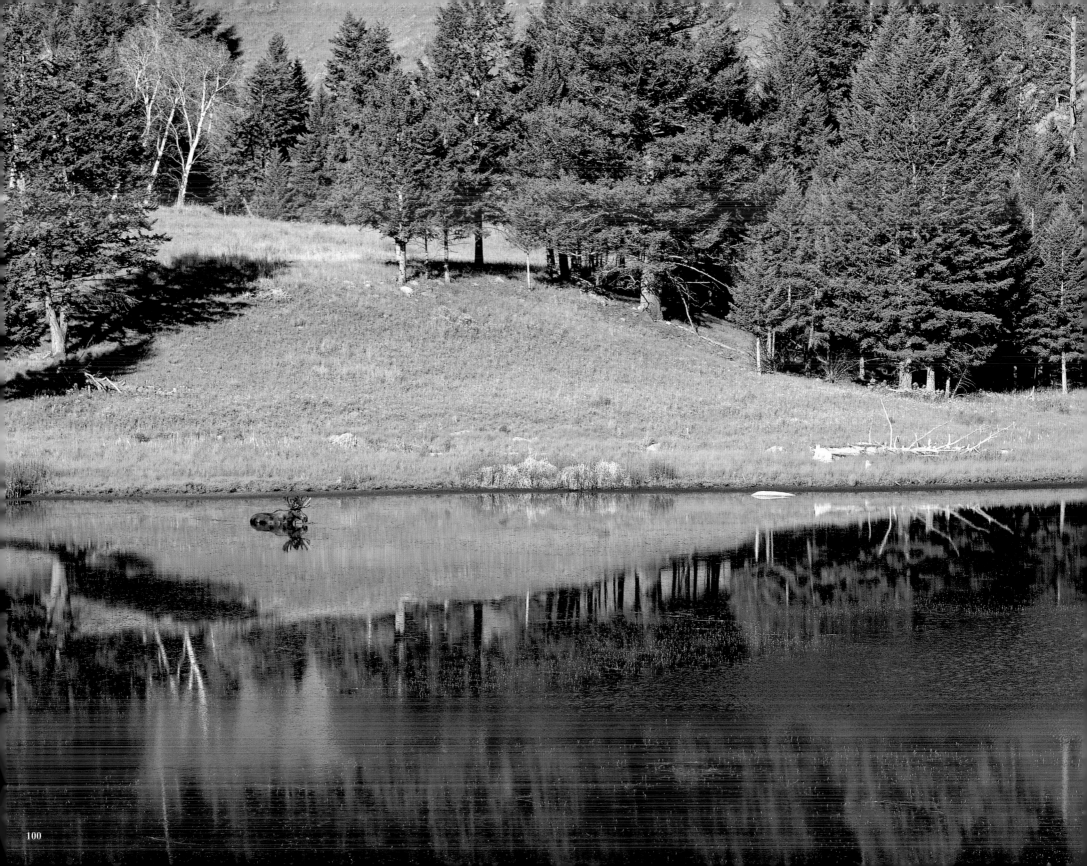

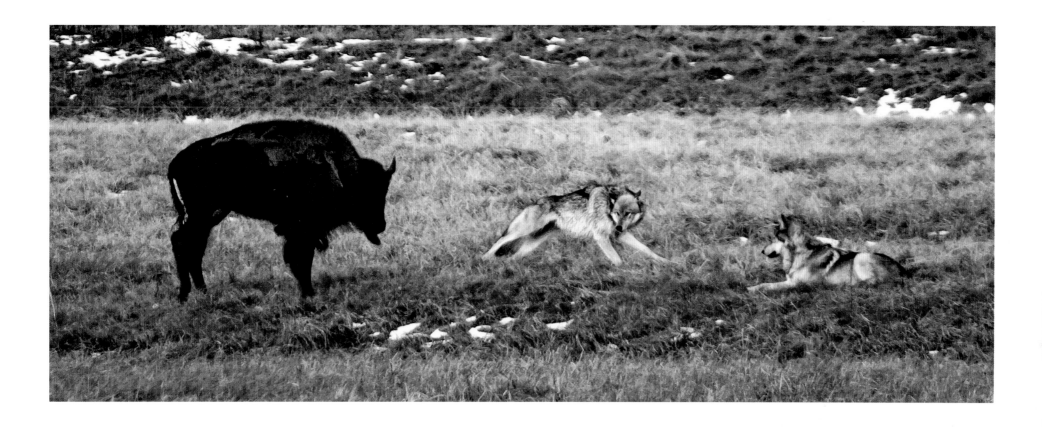

Right and above: Dances with bison. Things looked bleak for this young Yellowstone bison. Then the sun came out and she fought back. The wolves eventually gave up and went looking for easier prey.

Facing page: A bull moose stands belly-deep in Floating Island Lake. Technically a member of the deer family, moose could almost be classified as amphibians for as much time as they spend in the water. Their numbers have declined since the 1988 fires and the subsequent wolf reintroduction in 1995.

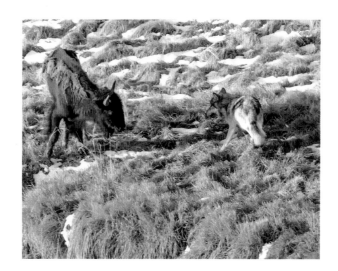

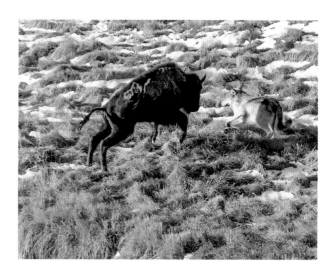

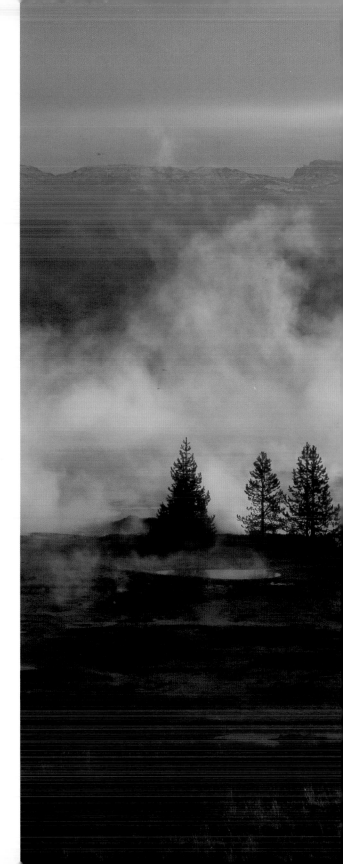

The western fringed gentian grows mostly in open marshy meadows and thermal areas like West Thumb Geyser Basin (right). For that reason, it has been named the official Yellowstone Park flower. The West Thumb bay was named for its location in Yellowstone Lake, first described by early cartographers as resembling an open hand. This area epitomizes Yellowstone with its abundant wildlife, lakeshore geysers, hot springs, and mountain vistas, all concentrated in one idyllic location.

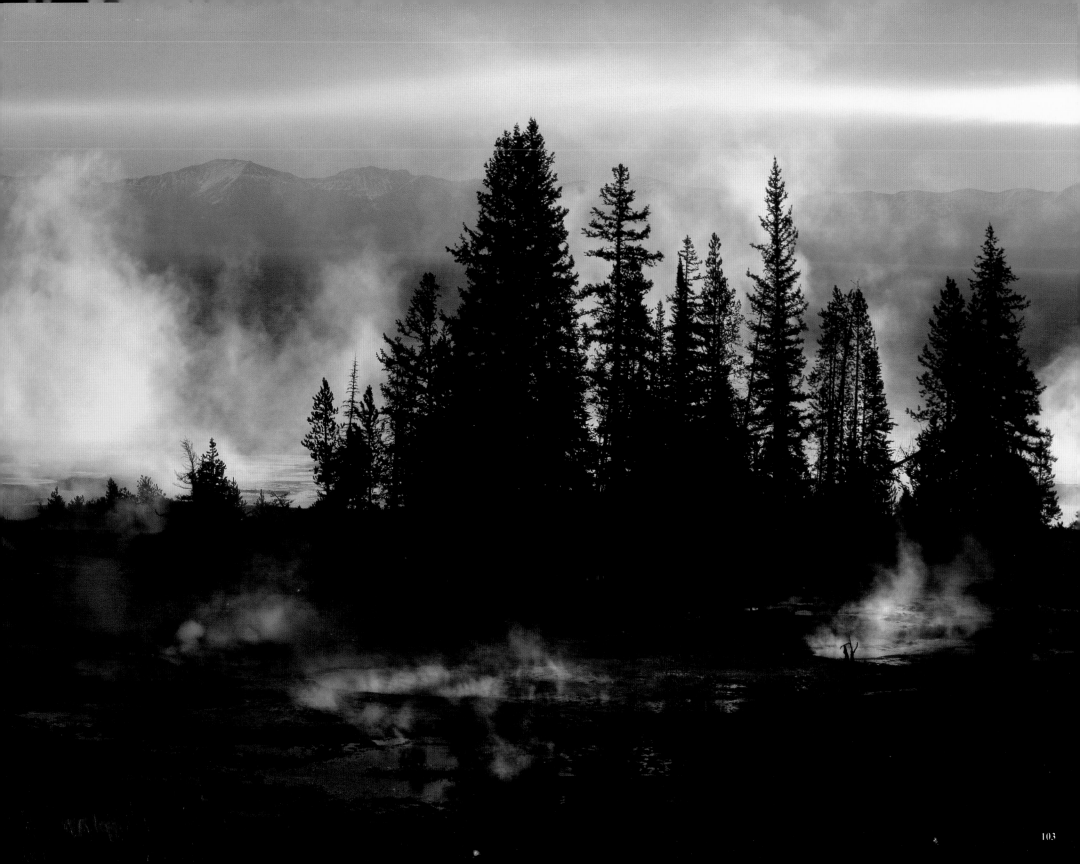

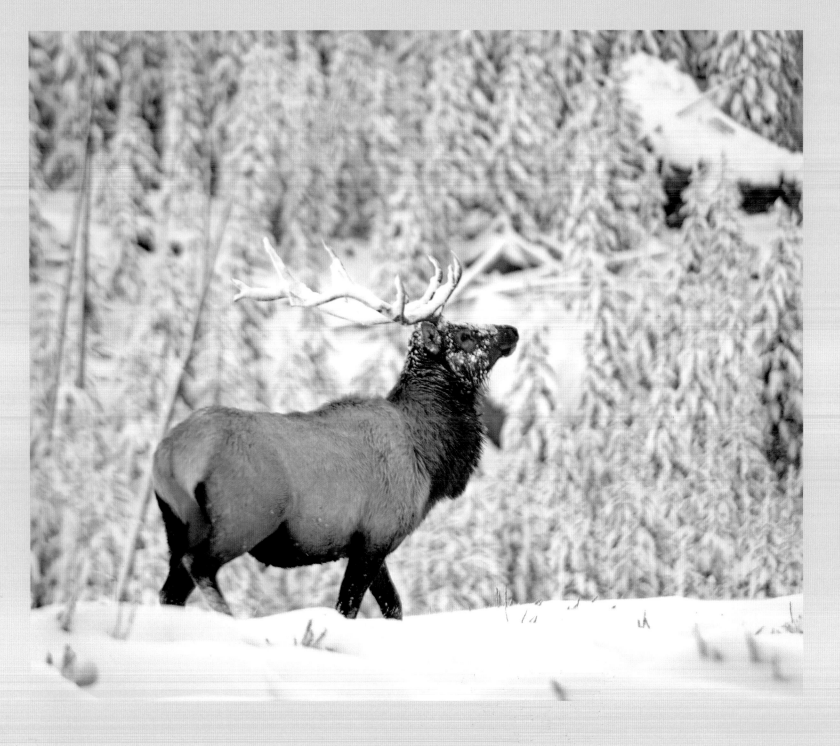

Left: This bull elk woke up to over a foot of fresh snow in Madison Canyon.

Facing page: In 1870 Nathaniel Langford of the Washburn Expedition had this to say about the Canyon area: "A grander scene than the lower cataract of the Yellowstone was never witnessed by mortal eyes."

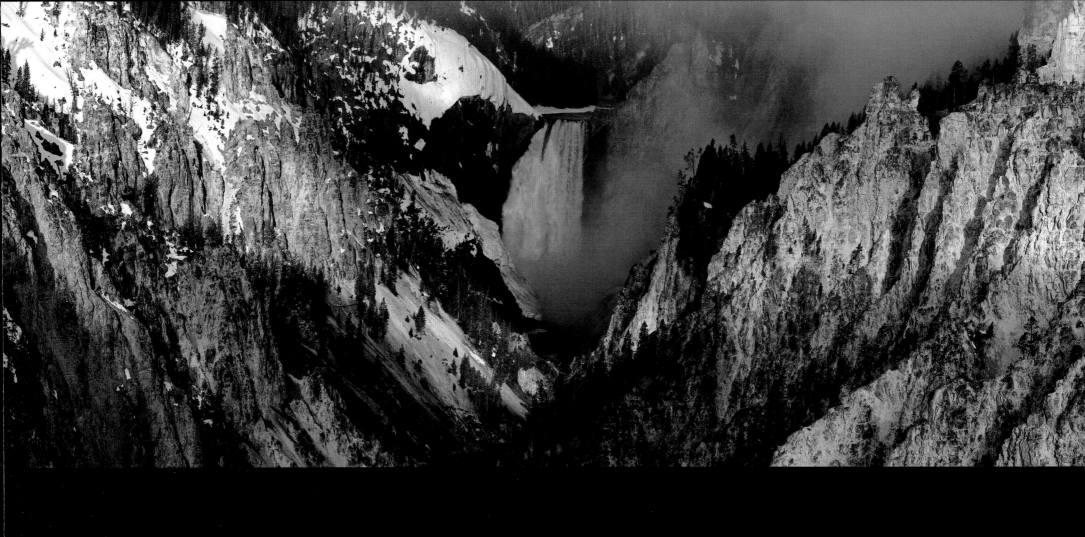

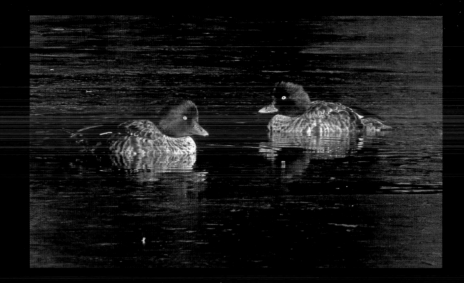

Right: Female Barrow's goldeneye.

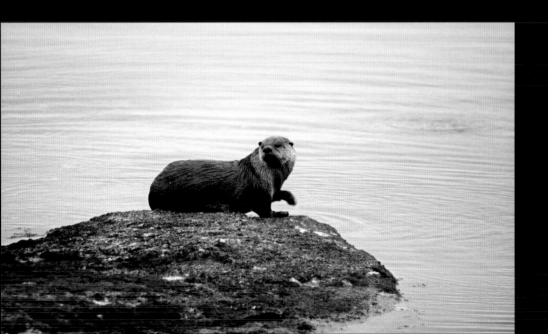

Left: Despite West Thumb Geyser Basin draining roughly 3,100 gallons of boiling water daily into this shallow arm (or digit) of Yellowstone Lake, its waters maintain a frigid average summertime temperature of 42 degrees Fahrenheit. Even this otter appears to have second thoughts about taking a dip.

Facing page: The Lower Falls of the Yellowstone River through a window of clouds.

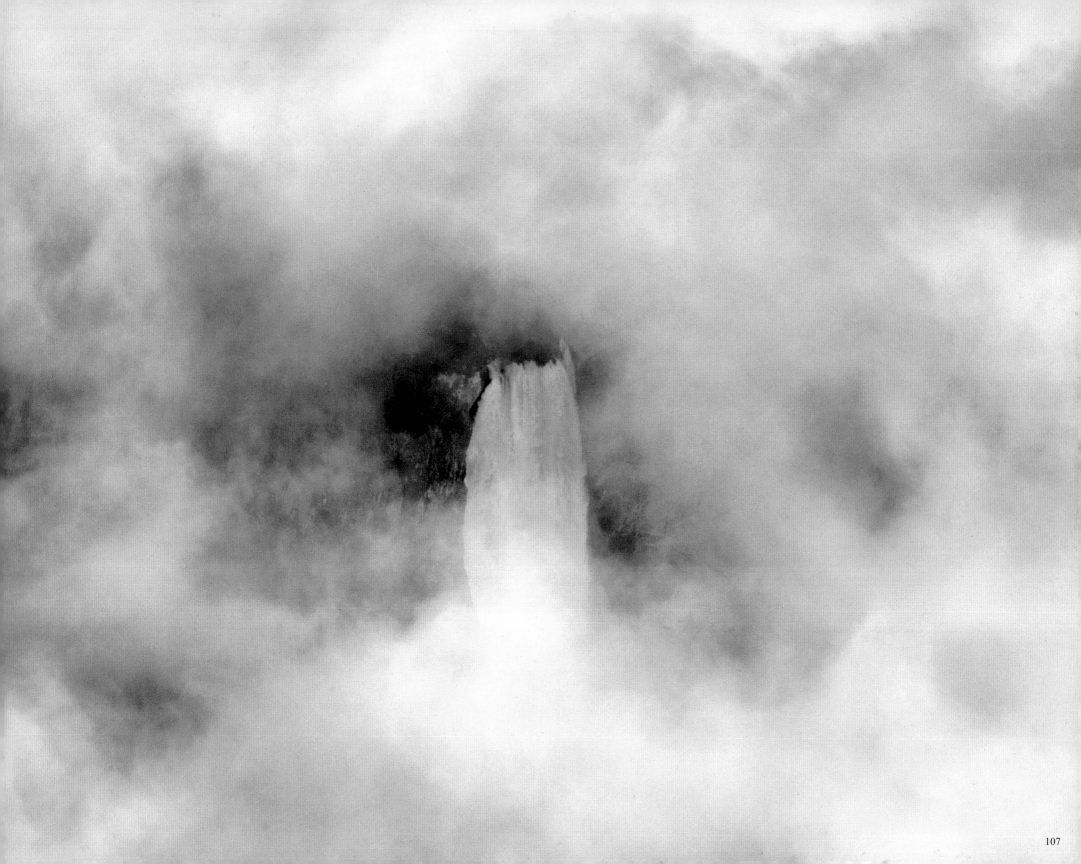

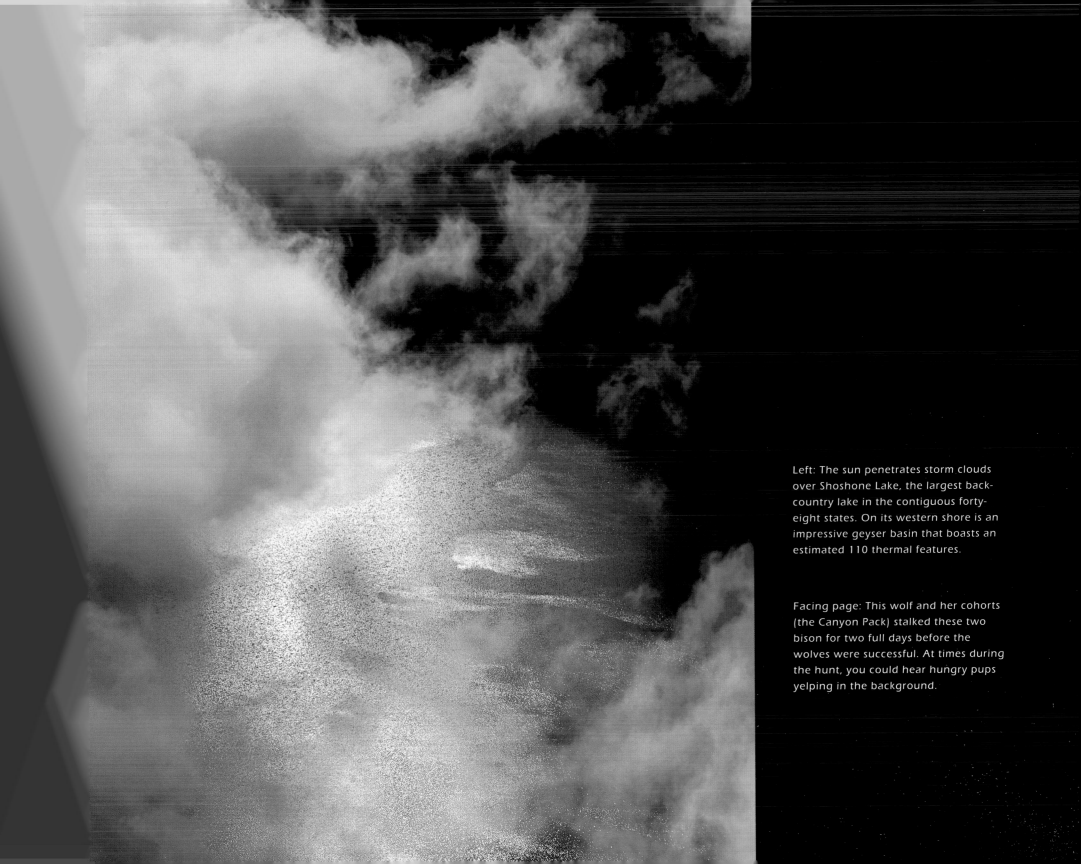

Left: The sun penetrates storm clouds over Shoshone Lake, the largest back-country lake in the contiguous forty-eight states. On its western shore is an impressive geyser basin that boasts an estimated 110 thermal features.

Facing page: This wolf and her cohorts (the Canyon Pack) stalked these two bison for two full days before the wolves were successful. At times during the hunt, you could hear hungry pups yelping in the background.

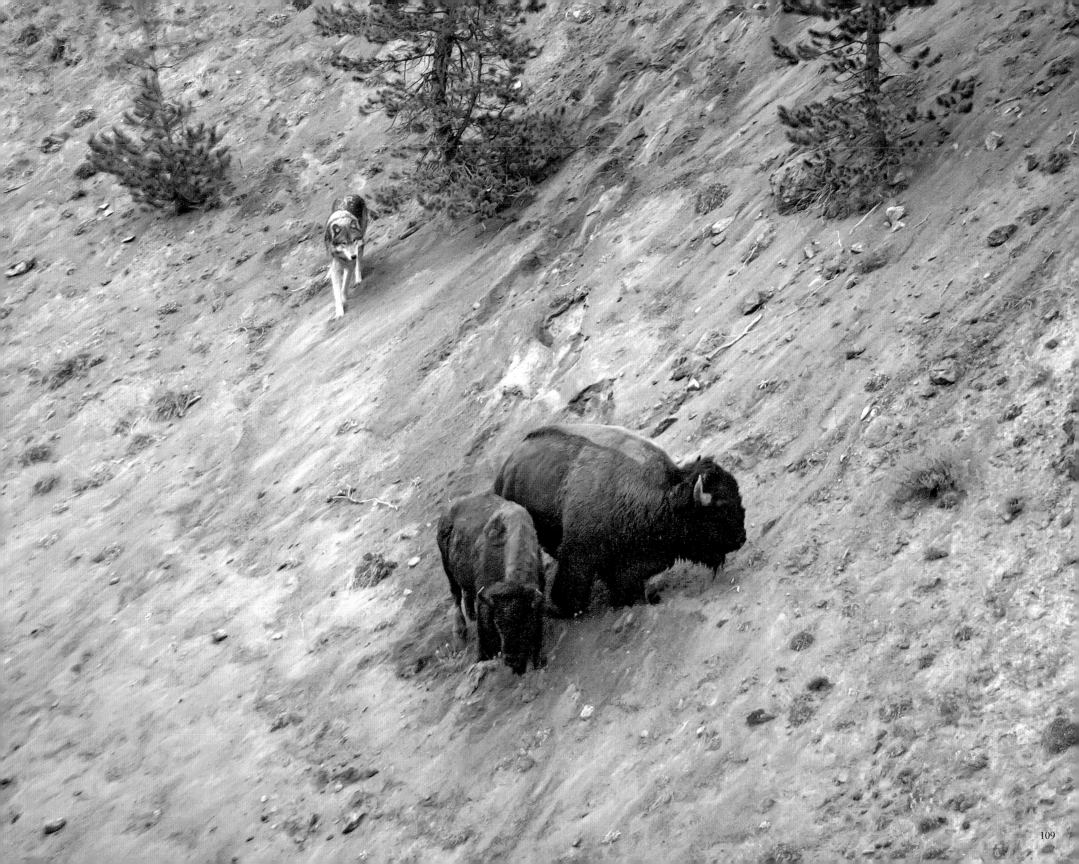

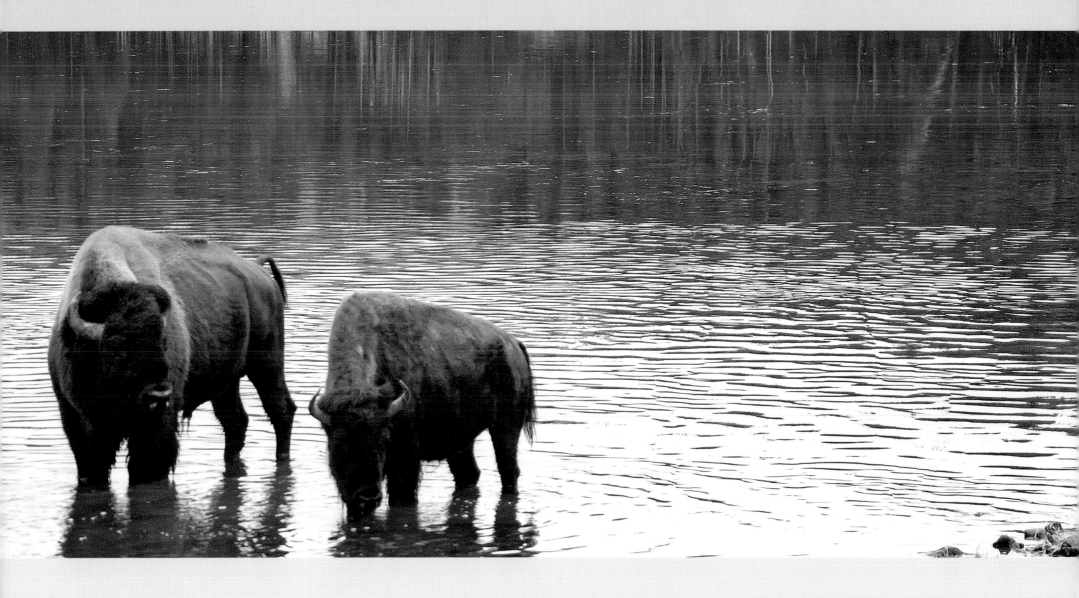

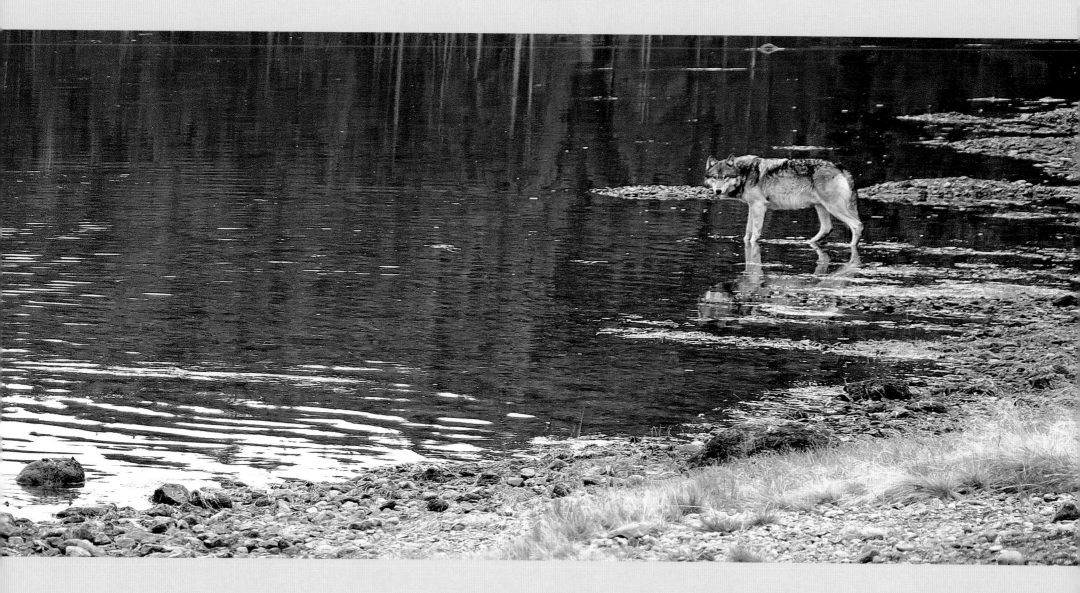

The "stalker" along the Yellowstone River.

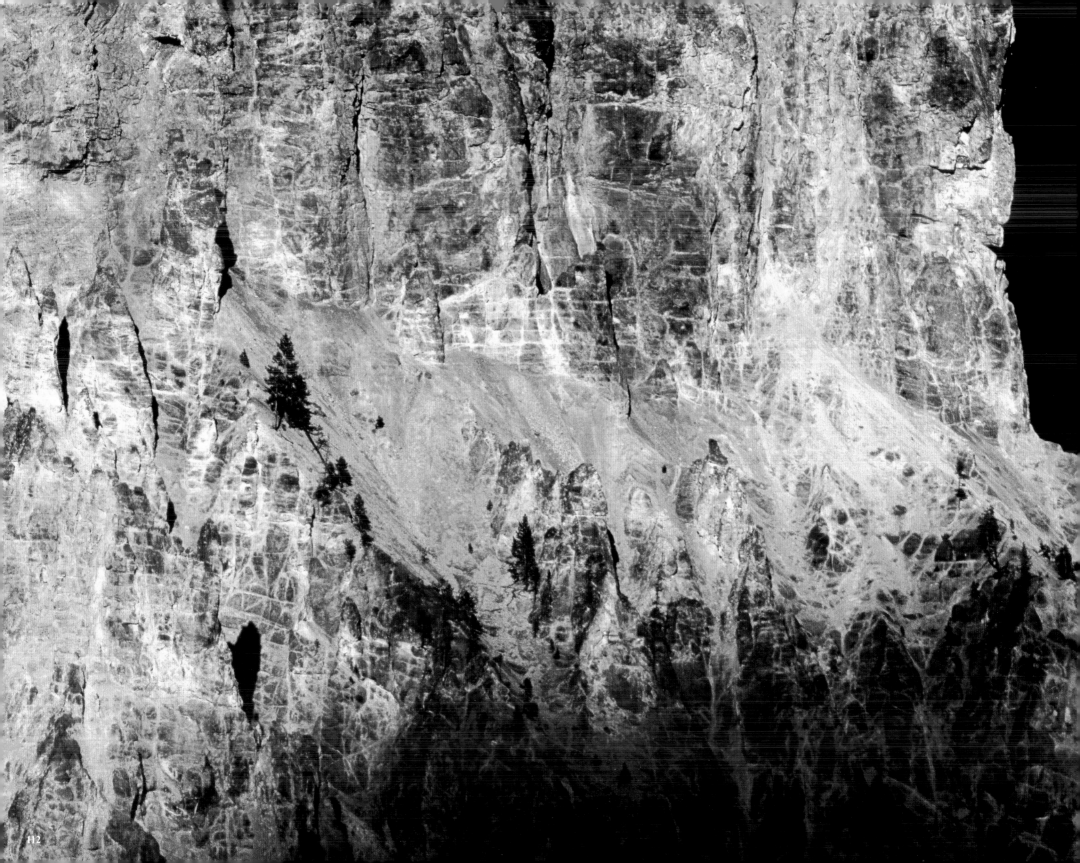

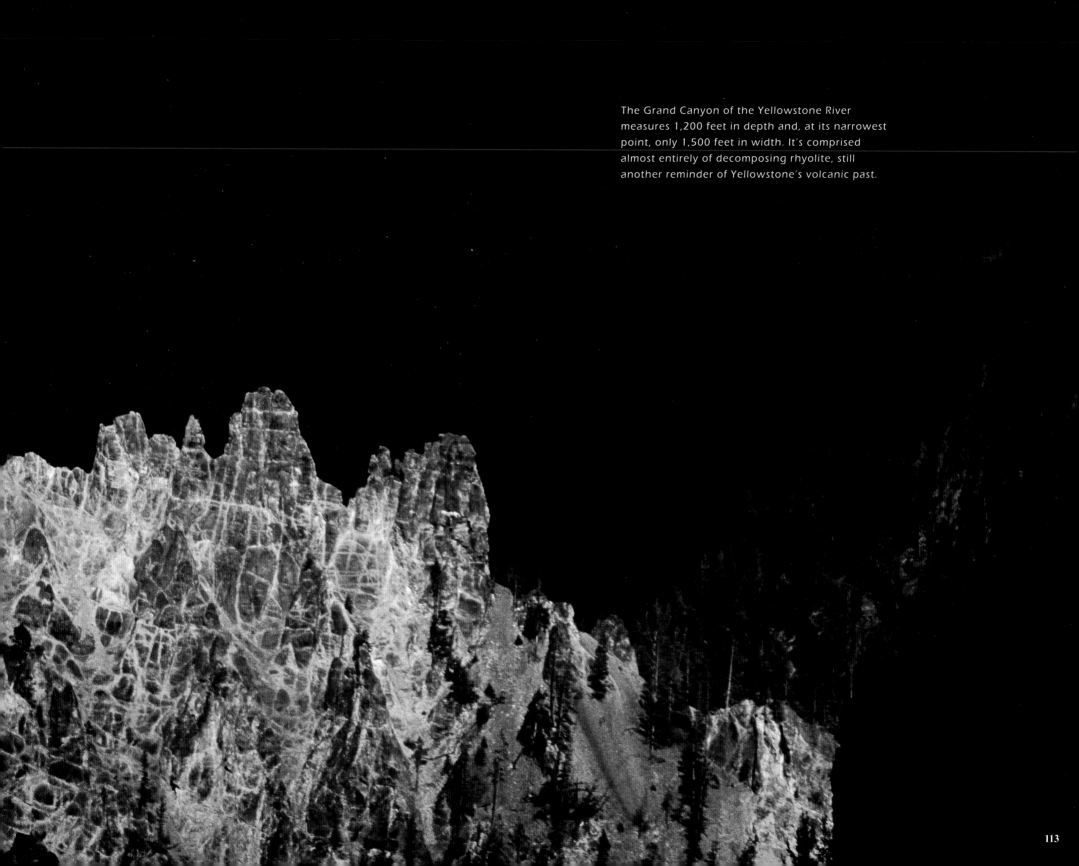

The Grand Canyon of the Yellowstone River measures 1,200 feet in depth and, at its narrowest point, only 1,500 feet in width. It's comprised almost entirely of decomposing rhyolite, still another reminder of Yellowstone's volcanic past.

Hayden Valley has been called the "American Serengeti"—and for good reason. The bull elk below looks out at a distant herd of bison while standing between his harem of cows and a lone coyote. Coyotes have been described, by wildlife psychologists, as being paranoid optimists, as is the case with this pack pictured to the right. The grizzly is protecting her buried carcass from mildly paranoid, but hopelessly optimistic scavengers.

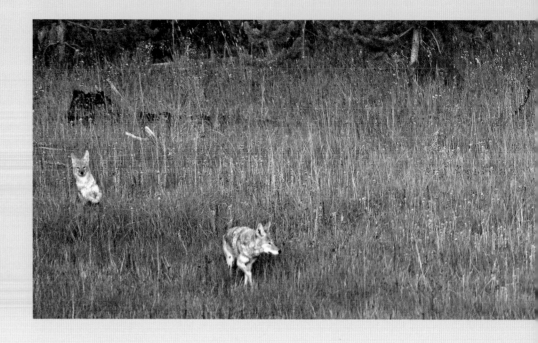

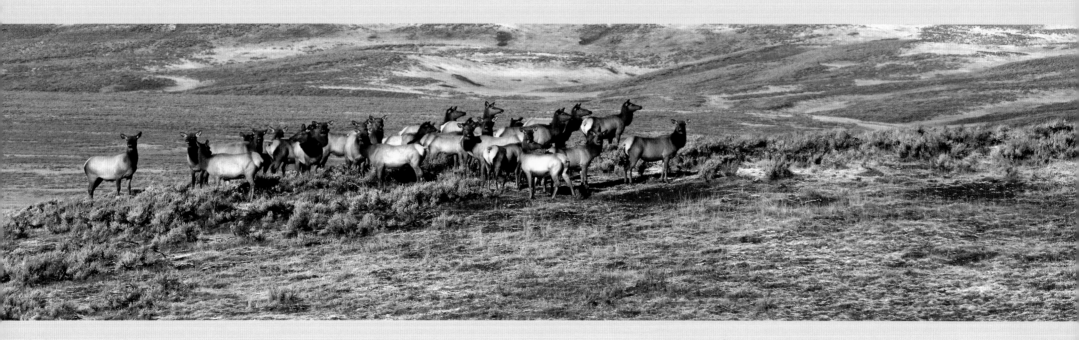

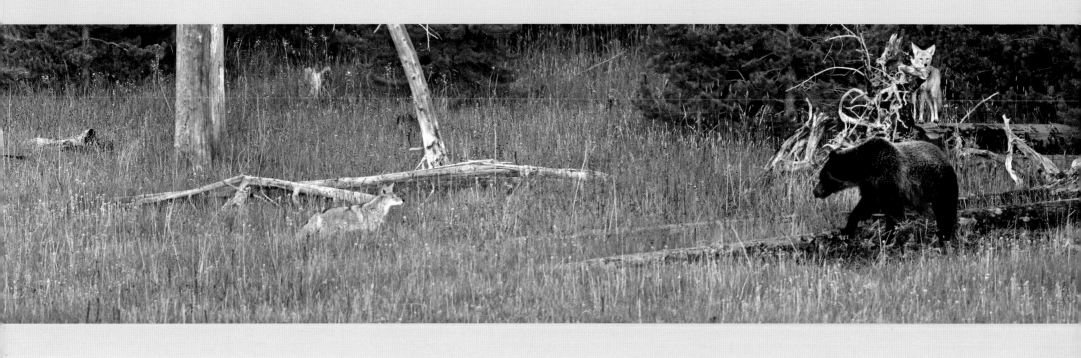

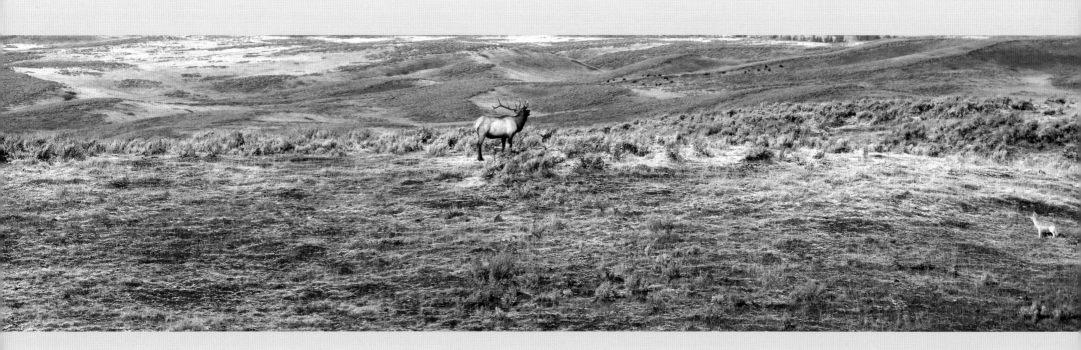

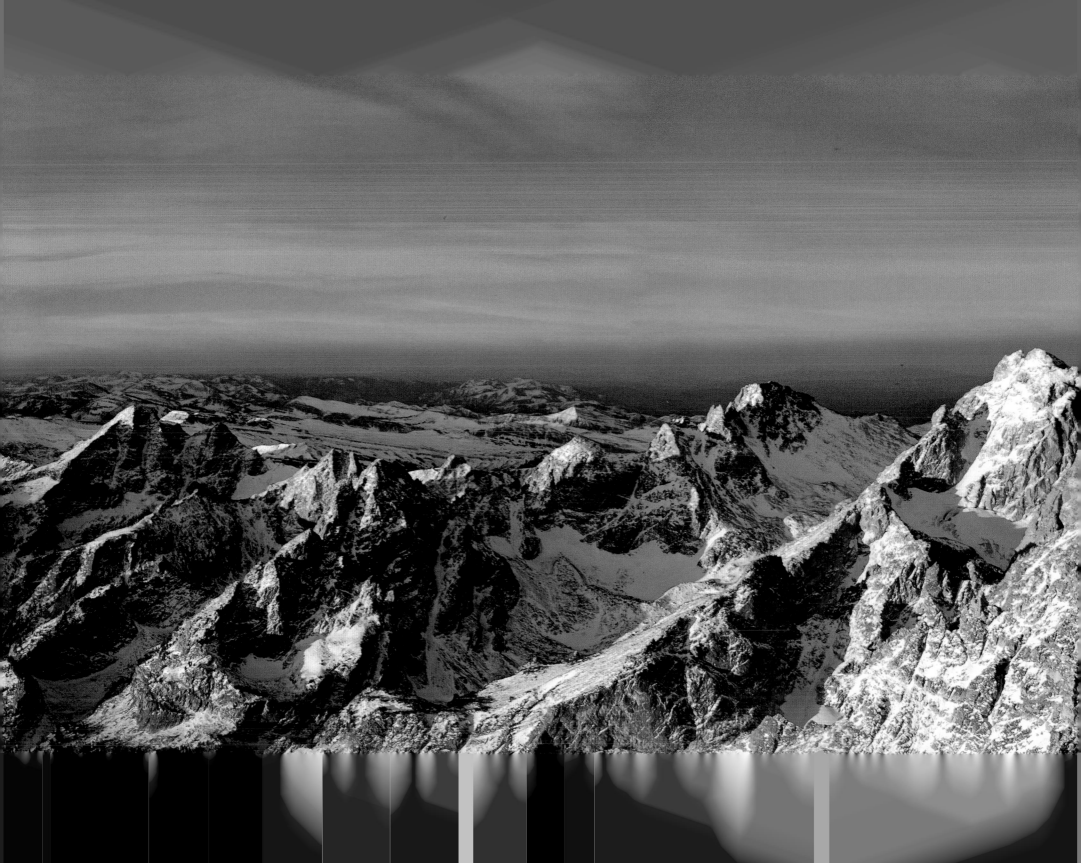

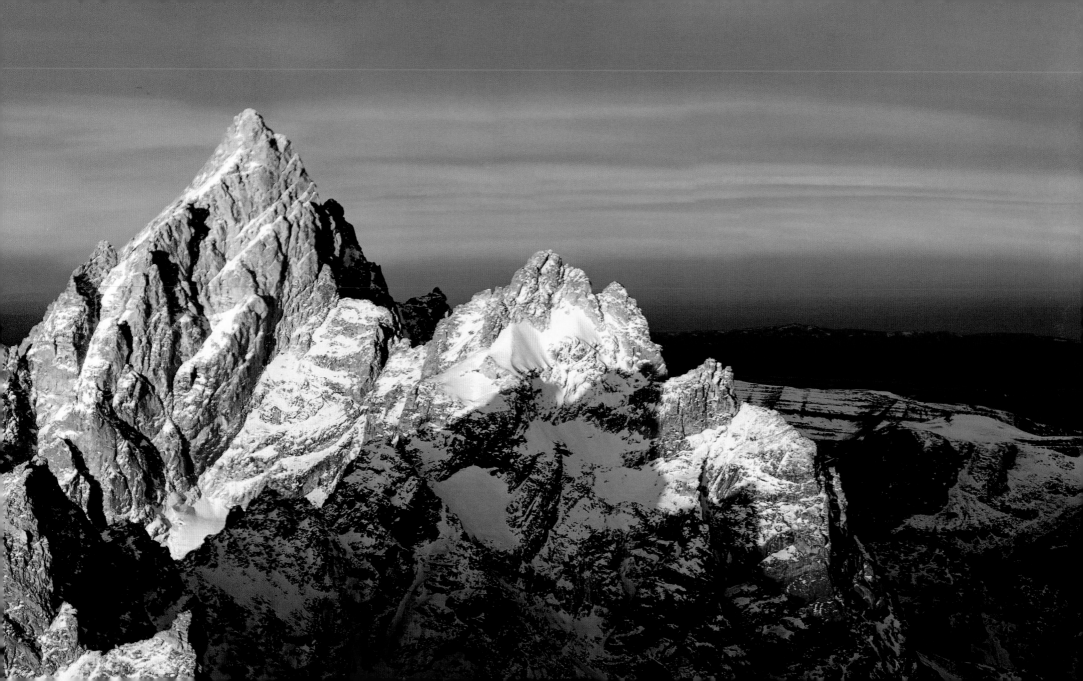

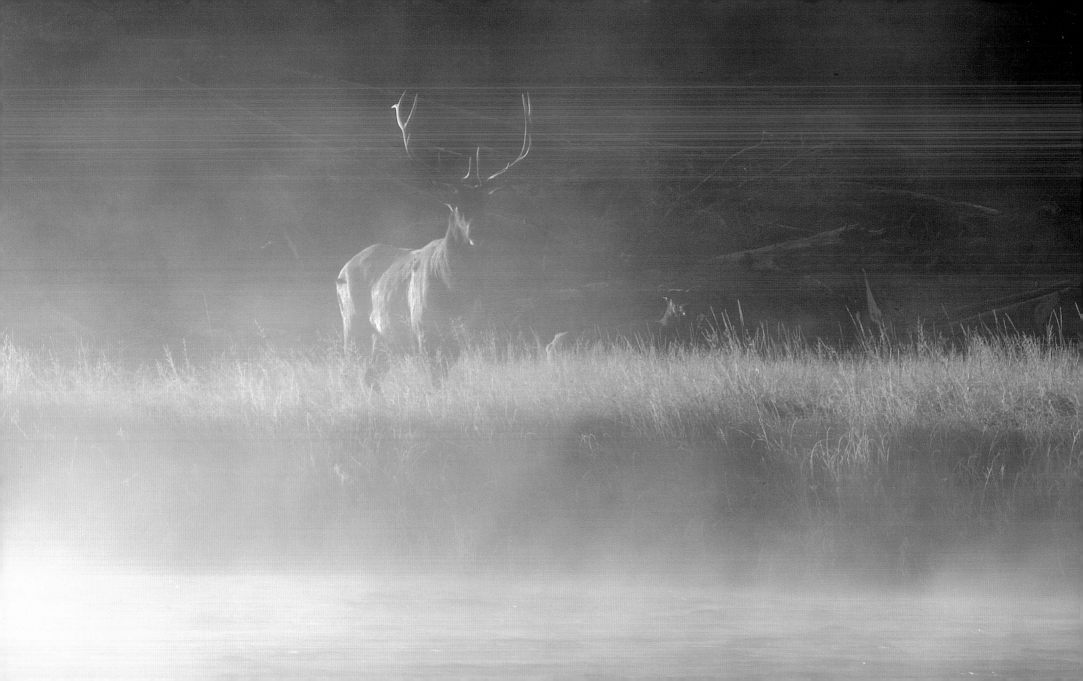

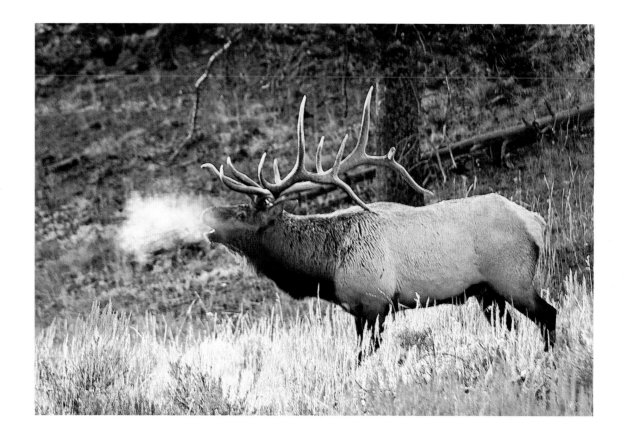

Above: As majestic and awesome as any animal in Yellowstone, the bull elk is even more impressive when heard bugling. It's an indescribable sound and one of the most memorable wilderness experiences anyone can have.

Left: A small bull with one member of his harem stands proudly at the banks of the Madison River.

Right: Perfectly "in the moment," a coyote pounces over its prey.

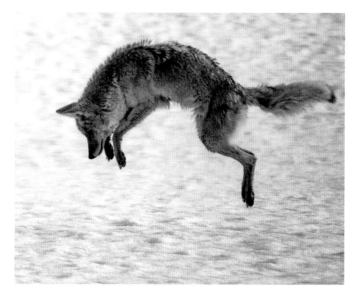

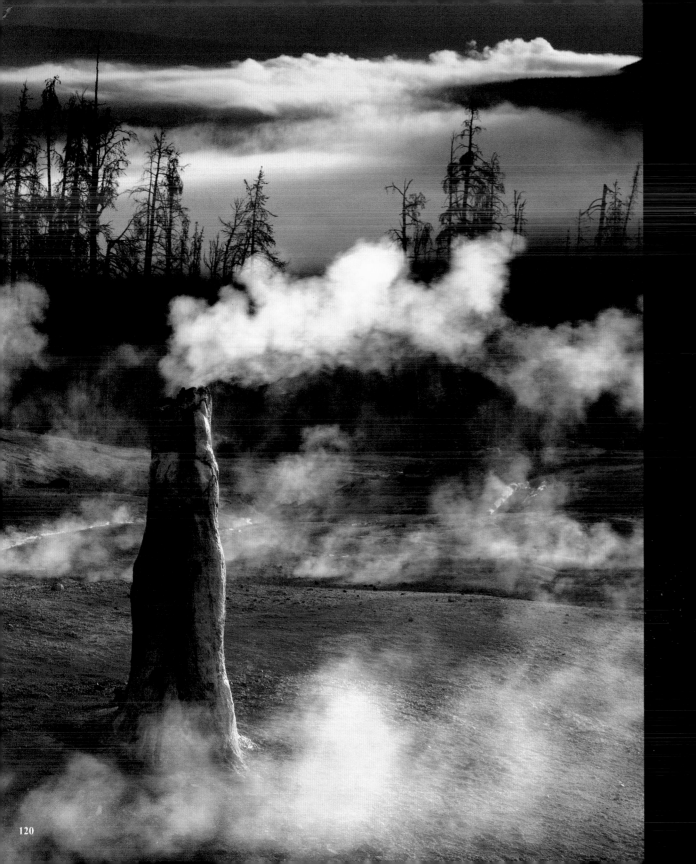

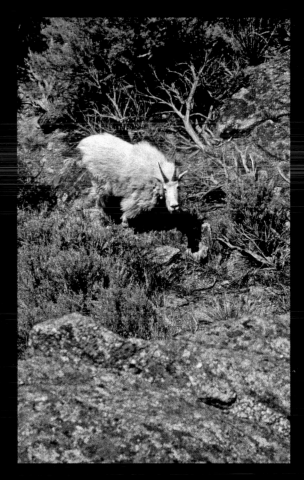

Above: This goat's-eye-view was photographed just outside of the park in the Clark's Fork Canyon. But the goat population in Yellowstone is increasing and many can now be viewed (most likely from below) on the slopes of Barronette Peak.

Left: Thermos Bottle Geyser, a 9-foot-tall sinter formation overlooking the Gibbon Valley, emits steam and occasionally small amounts of water.

Facing page: A grizzly cub peers out from underneath Mama.

Following pages: Elk are often heard before the fog lifts and they can actually be seen.

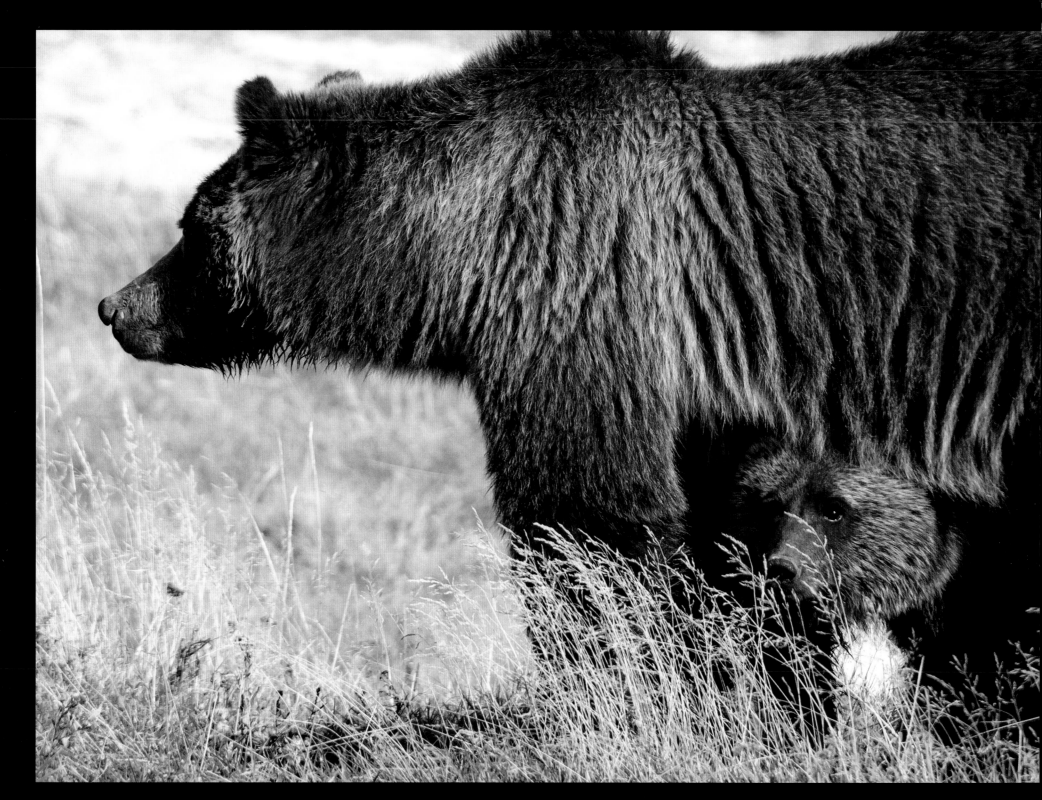

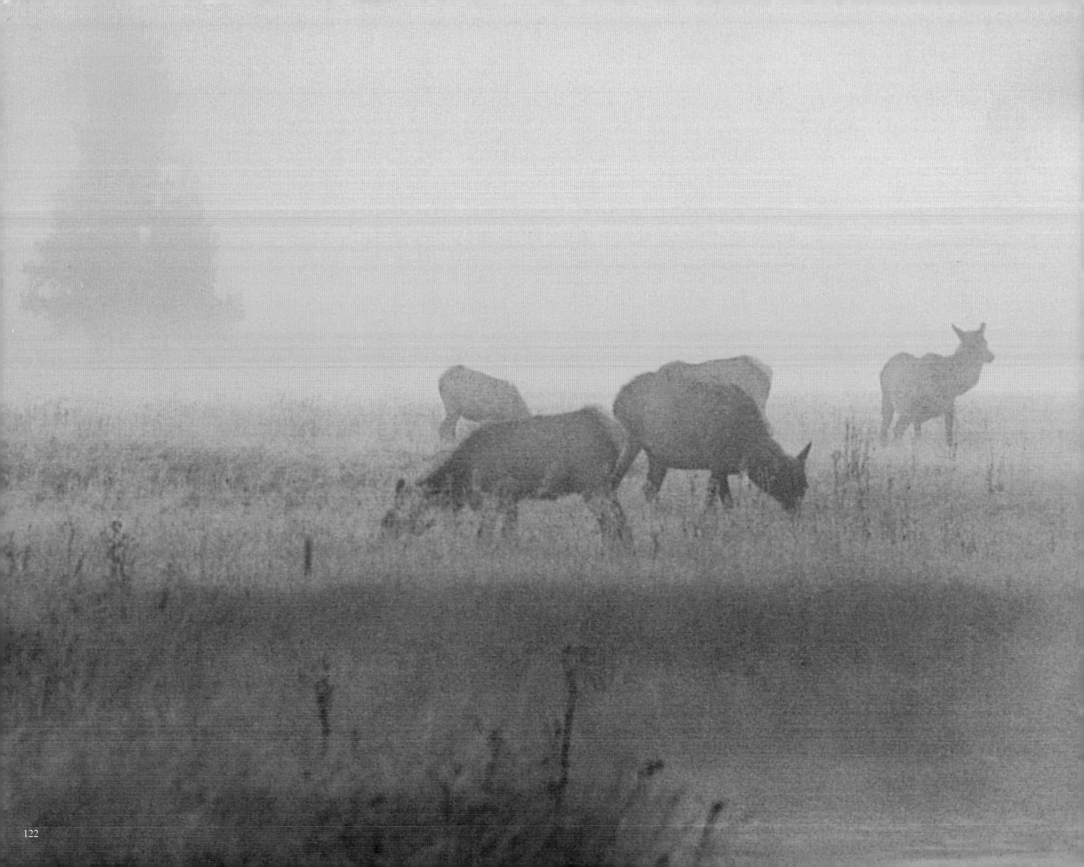

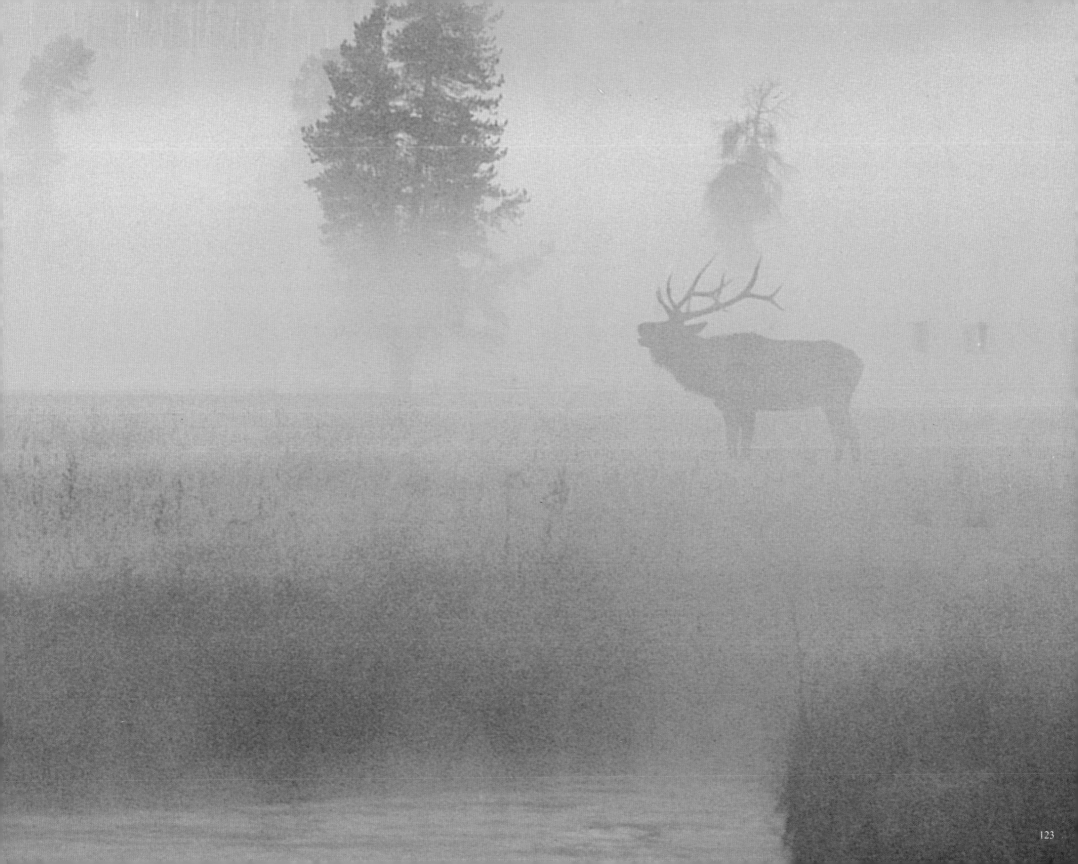

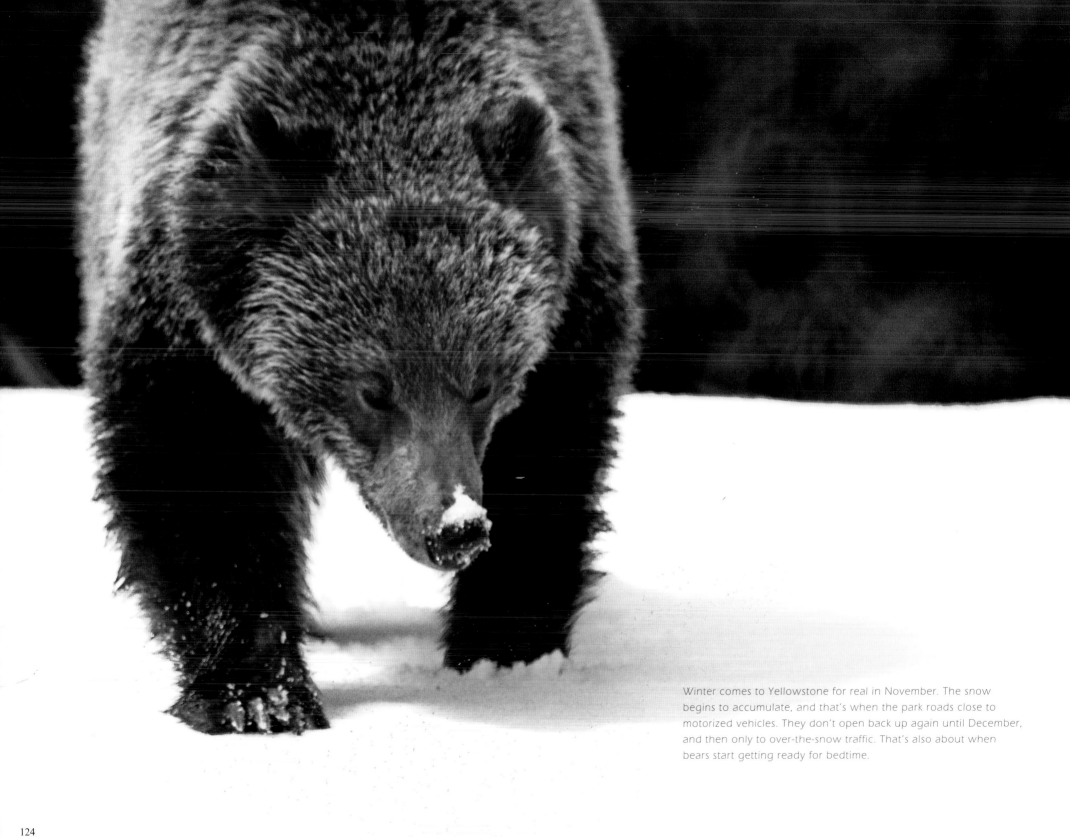

Winter comes to Yellowstone for real in November. The snow begins to accumulate, and that's when the park roads close to motorized vehicles. They don't open back up again until December, and then only to over-the-snow traffic. That's also about when bears start getting ready for bedtime.

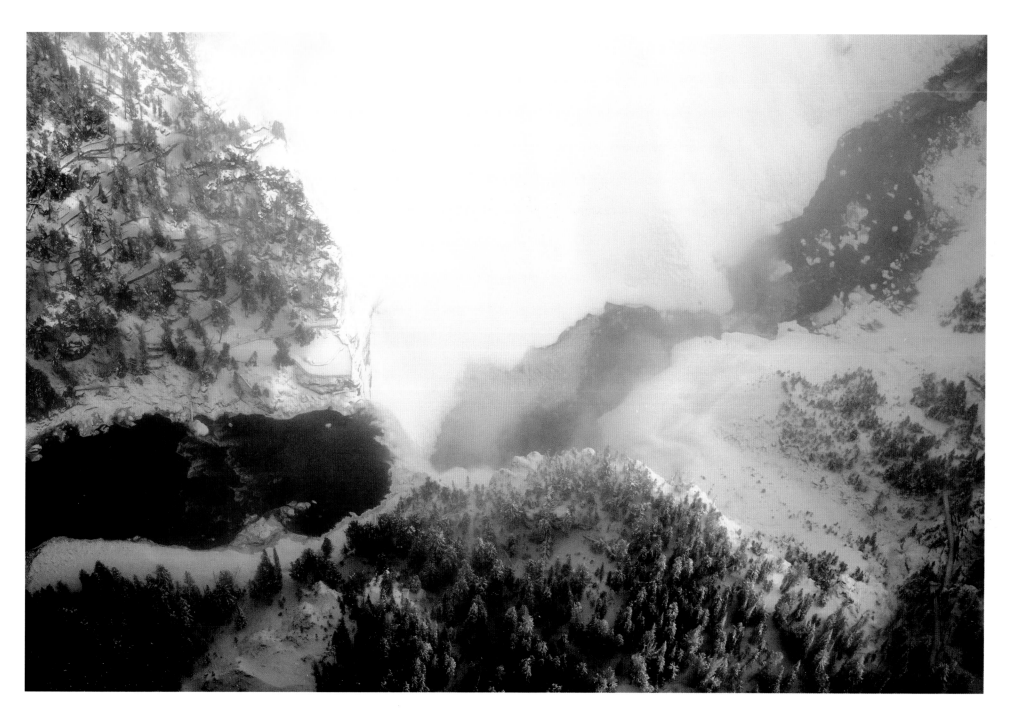

The brink of the Lower Falls from directly above.

Facing page: A cow elk in the Yellowstone River.

Right: Tower Fall aerial.

Below: Mountain bluebird.

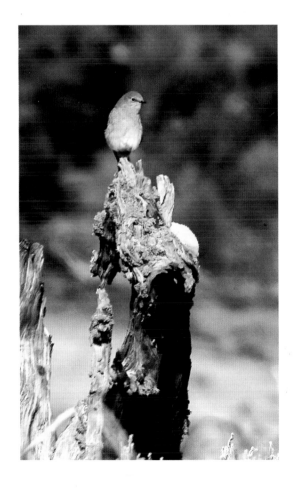

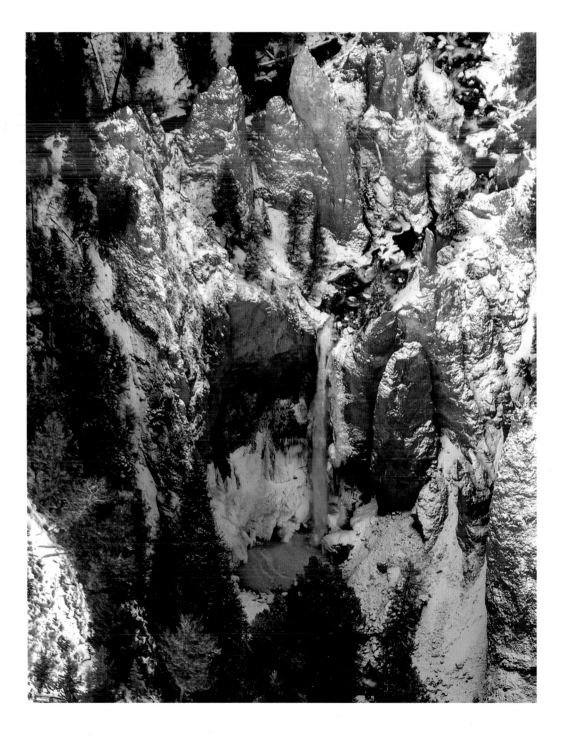

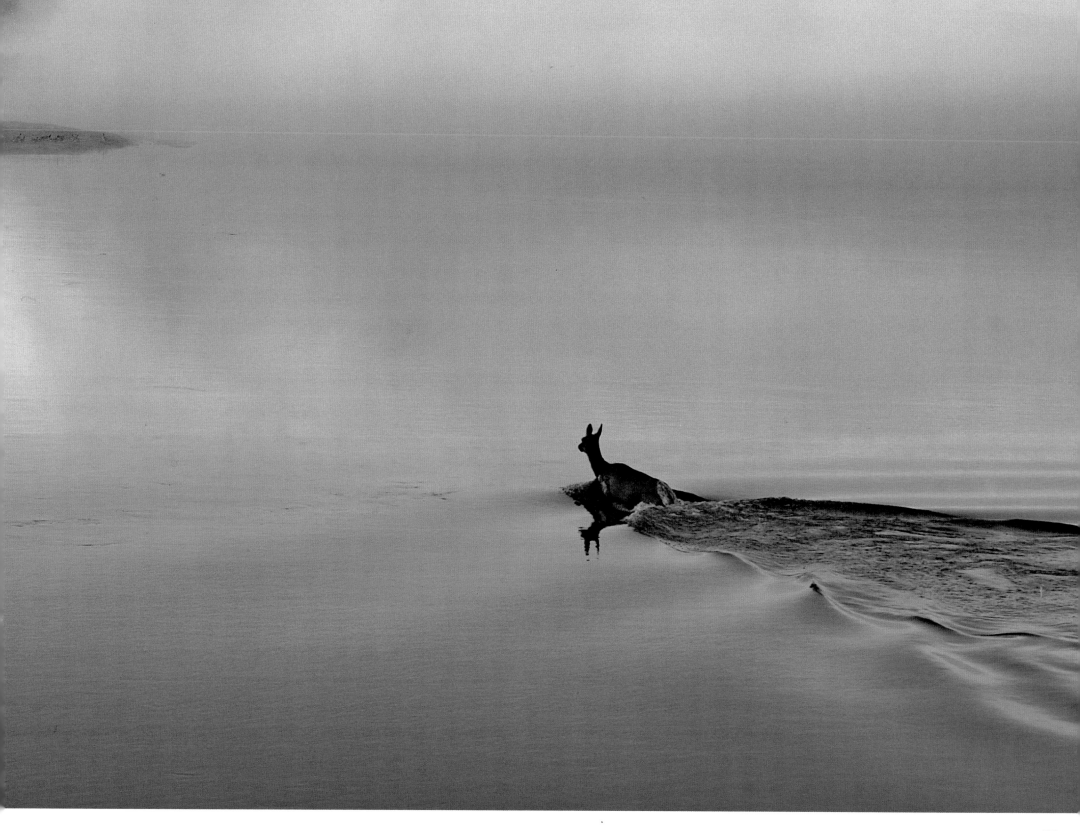

Dave Peterson has been photographing Yellowstone since 1983. He bought his first professional film camera in 1988 and has never looked back. Occasionally, though, he will look *down,* hand-holding his heavy Pentax 6x7 while focusing on Yellowstone from a small Cessna aircraft.

It wasn't until the new millennium that he bought his first digital camera (another Pentax), which, of course, made the aerial work a lot easier. In fact, this is the first of Dave's books to feature images taken with his entire collection of equipment: 35mm, 6x7, large format, and DSLR.